Stanisław Wyspiański

THE WEDDING

a drama in three acts

first presented in Cracow, 1901

translated by
Noel Clark

Introduction by Jerzy Peterkiewicz

OBERON BOOKS
LONDON

First published in 1998 by Oberon Books Ltd.
521 Caledonian Road, London, N7 9RH.
Tel: +44 (0) 20 7607 3637/ Fax: +44 (0) 20 7607 3629
Email info@oberonbooks.com
www.oberonbooks.com

Reprinted 2010, 2012

British Library Cataloguing-in-Publication Data
A catalogue record for this book is available from the British
Library.

ISBN 978-1-84002-041-0

Cover Illustration: Andrzej Klimowski

Typography: Richard Doust

Printed and bound by Marston Book Services Limited, Didcot.

Contents

THE STRAW-MAN AT A WEDDING

Jerzy Peterkiewicz

"An instant classic": this I read in the London Underground, on a poster advertising a film whose title I cannot recollect now. However, I still remember the instant-classic phrase, because it advertises an impossibility. A classic, any potential classic, has to endure a test of time: it has to survive many changes of fashion and emerge from each of them still fresh, and intriguing enough to attract a new public. This is certainly evident in the history of the theatre where permanence is such an unreliable proposition.

Now I have before me the task of justifying the claim that *The Wedding* (*Wesele*), a play almost a hundred years old, is a legitimate Polish classic. Moreover, my attempted justification cannot assume that every reader of this essay should be familiar with Polish literature, and the circumstances in which this particular piece of theatre came into being. In its native context the play is still very much alive: numerous productions, year after year, keep every successive generation aware of its authority as a work of art. It attracts new and gifted directors, partly because the central idea lends itself to reappraisal and experiment. That central idea appears to be relatively simple: the wedding in question is between a poet from town, the town being Cracow, and a very young peasant girl from a nearby village. Such a wedding did, indeed, happen.

The festivities took place in a cottage which resembled a nobleman's countryhouse: in fact, it was owned by a man of noble birth, a painter who had ten years earlier married the Bride's sister. The future author of the play, like other guests from Cracow, was invited to his friend's wedding. With an artist's acute observation of detail, Wyspiański witnessed the colourful social mingling between village and town on that November evening of 1900. His dual sensitivity, that of painter and poet, was fully engaged. The event being so authentic, and authenticated further in years to come, had to leave a legend rich in gossip and mystery. Such legends usually spring from the conjunction of opposites, to borrow a mystical concept, and Cracow at the turn of the century was an ideal cradle for dreams of some national

cohesion which would finally bring freedom to the whole of the partitioned country.

Cracow, the seat of kings with its imposing castle on a hill, was still under Austrian rule, an offence in Polish eyes, although the Habsburg administration was trying to inspire at least a semblance of loyalty to the Kaiser in Vienna. Stanisław Wyspiański, born in Cracow in 1869, saw the past enshrined in its streets, every day he was walking in the museum of history: his imagination communicated with its ghosts who claimed his allegiance.

As for the peasants, the little-known inheritors of the same past, their presence had to be noticed. They had to be painted by artists, described by poets, their rural culture idealised, in order to remove the stain of guilt from the nobles and the intelligentsia. After all, the peasants were not responsible for the partitions. No unity could be achieved without their participation: they were the earth-bound majority, which was a silent majority. How could they be won over, and brought closer to the dream of independence? The unity of wedded opposites was, no doubt, a poetic idea – but it soon grew into a practical proposition, especially among Cracovian artists. Fall in love with a village lass, preferably young and pretty, court her in an idyllic setting of orchards and meadows, then marry her for the greater and purer glory of the Polish ethos.

The guests present at that November wedding were later asked many questions about Wyspiański, the begetter of the legend. He didn't dance at all, spoke very little: people said they remembered him leaning against the frame of one of the open doors, and just watching, watching. He was absorbing the mysterious reality of the cottage with his eyes and his ears. Outside, in the growing darkness, there stood among the trees a rose-bush protected with straw against frost, waiting for its resurrection in the Spring. The bush was rigid and watchful, too. How ingenious it was for the dramatist of Wyspiański's visionary mind to make the Bride invite the Straw-man i.e. the bush (*chocho*) to come and join the wedding guests. A jocular gesture of hospitality, which the creature does accept and turns up in Act II, when night falls and the guests

are drowsy from drink and dancing. Wyspiański's concept gives the play a new and startling dimension. The Straw-man begins a nocturnal wake. The characters, whether from town or village, are subjected to interrogation in depth, and the interrogators are phantoms. One after another they appear and try to break into the minds of the living. The characters are in turn forced to question their own identity. A Pirandello-like situation. Who are they really, here in this cottage, assembled for a wedding? And to what reality are they being wedded?

A famous Poet meets a mediaeval Knight about whom he wrote a poetic drama. An old peasant (*Dziad*) comes face to face with the leader of peasant rebels who in the year 1846, incited by the Austrians, butchered hundreds of their Polish squires, belying the illusion held by most Poles about the God-fearing docile villagers. The Journalist is interrogated by a sixteenth- century court Jester, wise and scathingly ironic. Finally, the Host of the wedding receives the strangest visitor of all, a Prophet from the Ukraine (he is portrayed in a picture hanging on a wall) who brings the promise of an imminent resurrection for Poland, and hands the Host a golden horn, a Wagnerian sort of call to magic.

But things do not turn out well: the wedding of promise ends at dawn in the dance of stupor. How strange are coincidences in the realm of imagination. At the same time when Wyspiański created the concept of his play, Edvard Munch was painting his *Dance of Life*, demoniacally menacing. The psychological *conjunctio oppositorum* in *The Wedding* seems to have worked in reverse: the confrontation instead of healing exposes the weakness of the national ethos.

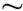

The Cracovian village with its cottage, where symbolic characters play the music of enchantment, where history sends its contradictory messengers, had given birth to a theatre of extraordinary power, which affected the mood of Polish literature for many years, and is still lodged deep in the consciousness of Poles. Wyspiański's classic – and undoubtedly it is that – opened a secret door to the Polish twentieth century, letting in symbols capable of transforming themselves into new ideas, shaped by psychology and by reappraisals of historical events. The phantoms of Act II are invoked by his poetic instinct from

collective memories which, being communal, can therefore be brought to the surface by anxiety or shame shared by many. The archetypal probing goes much deeper into shared memories than any individual recollection. Hence the emotional value of a theatrical effect which conjures up what is concealed by the mind because of fear or guilt.

The Symbolist artists at the turn of the century knew how to apply a shock therapy to their ideas in poetry, painting, or music. The Symbolist in Wyspiański could do this in words and in painting, but he also had a strong need for musical effect in his dramas. His early short play *Warszawianka* (1898) uses music as an overall symbol: its title is that of a song written by a Frenchman to honour the Polish uprising of 1830. But what happens on the stage is static: a group of commanding officers talk in monologues and wait, the battle is waged in the fields outside, only the song and a solitary messenger give a dramatic cohesion to the passing of time. Maeterlinck used this static kind of suspense in order to build up the atmosphere slowly, and control it like an instrument. The German word *Stimmung* described this, and was well known by artists in Cracow, so much so in fact that Wyspiański used the Polish equivalent of *Stimmung* in the angry, almost brutal, ending to his second act of *The Wedding*.

The muted effects in the first act are intentional. The musicians are not on the stage, nor are the dancing couples. Wyspiański places his characters, mainly in pairs, conducting their dialogue. Couples enter, talk and leave the stage to join the dancers. As a device it works well because the atmosphere is measured by entrances and exits which are controlled by their admirable brevity. The characters, too, are quickly sketched by words which seem to act like strokes from an artist's brush. And, indeed, Wyspiański shows a painter's hand in his stagecraft. He is very precise in descriptions of the chosen objects: every item displayed, be it a picture or a sabre, or a kitchen broom, is chosen in relation to what happens in the course of the action.

The overall effect of such structural elements depends on a triple coherence between language, music and visual objects. The visual dazzles by the variety of costumes: embroidered blouses, strings of coral beads, ribbons of manifold colours, peacock feathers on caps, the nobleman's robes, and town girls' dresses *à la mode*. Similarly, the phantoms parade their individual styles. Such

stimulation through different senses is defined as "synaesthetic", that is to say, a visual effect may find its meaning in a musical mode, and music, in turn, may interpret the meaning of speech. Wagner's fusion of ideas in his grand theatrical ventures was obviously a familiar model to emulate, Cracow was not that far from Bayreuth. Symbolists learnt much from the unifying tendency in every form of art, and though the élitist cry "Art for Art's Sake" was to be derided when the reaction set in, the cohesive practice of the great innovators, like Maeterlinck, Strindberg or Chekhov, produced enduring classics. Wyspiański's originality belongs to this rich stream of innovations.

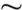

Closer to home, Wyspiański's familiarity with regional customs found a most attractive model to use: the puppet Nativity-play (*szopka* in Polish), performed from time immemorial in villages all over the country. The wooden frame with its small stage inside and a Bethlehem star shining above, was carried from house to house at Christmas time. The puppet characters included the wicked King Herod, the Devil and Death. The verses spoken were handed down by tradition: short spiky lines, frequently capped with funny rhymes, easy to preserve in memory. Folklore made doggerel verses sound attractive; it elevated them to a stylistic significance.

Wyspiański couldn't have found a more suitable rhythmic pattern for his dialogues. Moreover, he absorbed nuances of peasant speech at home, from his wife. He used them naturally and created a sound, characteristic of his verse, the Wyspiański sound. It allowed for quick verbal contrasts, from anger to incantation. No other Polish text in this century cast so many easily remembered quotations as *The Wedding*, some of them as quaint and charming as those from *Alice in Wonderland*. So, in the end, the triumph of his language exercises a magical power over audiences, and by contrast the same magic must have caused a resentful reaction, tinged with fear, in a few very distinguished men of letters, like Sienkiewicz, author of *Quo vadis*, who walked out in the middle of the performance. Think of parallel examples: the first performance of *The Rite of Spring*, the scandal over *The Playboy of the Western World*, or the baffled dismissal of *Waiting for*

Godot. Truly authentic originality is awesome because it has the unpredictable authority of magic.

The third and last act of Wyspiański's drama may seem too long, but its length is due to the final procession of symbols, which in the manner of Maeterlinck is punctuated with silences, subdued in the moods of waiting, in the growing uncertainty. The peasants had come armed with scythes as their forefathers were under the great leader Kościuszko. The golden horn was to sound the call for uprising and join the tough though impatient peasants with the guilt-ridden intelligentsia and nobles. But the horn is recklessly lost, and now the Straw-man is in charge. He is to play the mocking tune of perdition on his improvised fiddle. First he gives orders to the confused village youth, the loser of the horn, and he obeys. The guests, disarmed, begin dancing in couples, moving slowly like puppets to the music of the Straw-man. The magic circle around them is their entrapment – the stupor hangs over their heads as the curtain falls, a terrifying verdict of Fate which, in a strange way, may purge Evil from the inevitable despair.

〜

The translator of *The Wedding* has to be equipped with a subtle and pliable mastery over the resounding echoes of his own language. Meanings are and must be oblique in a symbolic play, and in the case of Wyspiański's technique, rhymes acquire a paramount importance.

Noel Clark not only possesses the necessary skill in choosing rhymes from different semantic layers of language, but he instinctively seems to know how to match appropriate meanings within the sounds that enclose them. Perhaps he partly owes this to his experience as a translator of French, Dutch and German classics.

His brilliant English versions of Fredro's comedies, their humour deeply imbedded in the Polish idiom, served Noel Clark as a journey of exploration; the energy which he needed to achieve impeccable accuracy was evidently nurtured by his love of Poland's literature and the desire to understand the ethos of its people whom he first met as a very young man during the war.

It was a happy experience for me to be involved in the progress of his arduous work on *The Wedding*, to see with what imaginative skill and patience Noel Clark recognised and resolved many difficult stylistic problems which lie in wait for the translator, especially in the case of this particular play whose character depends on the poetic use of dialect and of elusive historical resonances. I admire his achievement all the more for it.

What is my wish for this Polish classic now wearing an impressive English attire? That it should win a deserved recognition as a European classic.

<div style="text-align: right;">

Jerzy Peterkiewicz
Hampstead, London, 1998

</div>

Acknowledgements

I am particularly grateful to Professor Jerzy Peterkiewicz for giving me the benefit of his knowledge and critical acumen at every stage of my work on *Wesele*. The original text is full of pitfalls and puzzles for the translator – not least, those parts of the dialogue in peasant speech. Jerzy answered my many queries with exemplary patience. All remaining imperfections in this English version are, however, my responsibility, not his.

For their help in tracing and providing illustrations, my thanks are due to Anna Błaszczak (Stary Teatr, Cracow), Prof. Zbigniew Łagocki (Akademia Sztuk Pięknych, Cracow), Wojciech Plewiński, Diana Poskuta-Włodek (Teatr Słowackiego, Cracow), Julius Multarzyński (Warsaw), Rafał Węgrzyniak (Pamiętnik Teatralny, Warsaw), and Elżbieta Wysińska and Krystyna Rabińska (Polish Centre, International Theatre Institute, Warsaw).

I also wish to thank Urszula Święcicka (formerly manager of Nowy Teatr, POSK, London), Dr Zdzisław Jagodziński, (Director, Polish Library, London) and his colleagues, and, not least, for their advice and support, Aleksandra Czapiewska (Director) and Elżbieta Łyszkowska (Deputy Director) of the Polish Cultural Institute, London.

NC

Notes on Text

Act I, Sc i

The Headman's question about the Chinese refers to the Boxer Rebellion (1900) organised by secret societies in North China, during which foreign legations in Peking were besieged. Order was restored by foreign forces in 1901.

Głowacki, a hero of the 1794 Battle of Racławice in which a Polish force largely consisting of peasants armed with scythes and commanded by General Tadeusz Kościuszko, routed a numerically superior Russian force, capturing the Russian artillery.

Act I, Sc xvii

Jobs as postal clerks were much sought after as the only posts open to women in the Administration of the so-called Austrian "partition".

Act I, Sc xxiv

The Piast Kings – Poland's earliest known rulers, popularly believed to have been the descendants of a peasant wheelright called Piast. Prince Mieszko I adopted Christianity for Poland in 966 and founded the first "historical" Piast dynasty which ended with the death in 1370 of Kazimierz the Great.

Act II, Sc vii

The 3rd of May, 1791 was a key date in Polish history. The Polish Parliament's adoption of an advanced, liberal constitution alarmed Poland's neighbours and started a train of events which culminated in 1795 with the partition of Poland between Russia, Prussia and Austria for the next 123 years. Not till the end of World War I, was Poland reconstituted as an independent, sovereign state.

Notes on Pronunciation

In the Polish original of *The Wedding*, the peasants speak the dialect of the Cracow region, which the author spells almost phonetically. In this translation, I have not attempted to give the peasants a dialect, though it is essential on stage that the speech of peasants, as opposed to gentry, should reflect the difference between 'town' and 'country'. A director will be the best judge of what the cast can offer by way of a rural accent accessible to a given audience.

POLISH NAMES	PRONUNCIATION
ISIA	EESHA
HANECZKA	HANETCHKA
MARYSIA	MARISHA
JADWIGA	YADVEEGA, YAGA, YAGUSH
WOJTEK	VOYTEK
MARYNA	MAREENA
ZOSIA	ZOSHA
CZEPIEC	CHEPIETS
CZEPCOWA	CHEPSOVA
RADCZYNI	RATCHINNY
KLIMINA	KLEEMEENA
JASIEK	JASZEK
KASIA	KASHA, KASHKA
KUBA	KOOBA
STASZEK	STASHEK
STAŃCZYK	STANCHIK
GŁOWACKI	GWOVATSKEE
SZELA	SHAYLA

The accent is always on the penultimate syllable.

Characters

HOST
a painter from Cracow who married a country girl
and is now a well-to-do farmer

WIFE
of Host, sister of Bride

ISIA
their young daughter

GROOM
a writer from Cracow; brother of the Host

HANECZKA
sister of Groom; niece of Radczyni

BRIDE
Jadwiga, also known familiarly as Jaga or Jaguś, a
peasant girl

FATHER
of Bride, a local farmer

MARYSIA
daughter of above and sister of the Bride

WOJTEK
husband of Marysia

MARYNA

niece of Radczyni

ZOSIA
niece of Radczyni

JOURNALIST
friend of Groom, from Cracow

POET
friend of Groom, from Cracow

NOS
friend of Groom, from Cracow

HEADMAN
Czepiec by name, *wójt* or village headman

CZEPCOWA
wife of Headman

RADCZYNI
widow of a Cracow city councillor

KLIMINA
widow of former village headman; she is also a peasant
farmer and match-maker.

PRIEST

JEW
inn-keeper

RACHEL
inn-keeper's daughter

JASIEK
best man

KASPER
chief bridesman

KASIA
chief bridesmaid

KUBA
stable lad

GRANDAD
elderly peasant

MUSICIAN

STASZEK

FARM HAND

APPARITIONS

STRAW-MAN
enigmatic figure from folklore who appears as a rosebush wrapped in straw to protect it against the frost.

GHOST
Marysia's dead fiancé

STACZYK
court jester of King Zygmunt the Elder (1467-1548)

HETMAN
Ksavery Branicki, leader of a treacherous group of Polish nobles, in league with Russian Czarina Catherine 2nd. Their conspiracy to do away with the liberal Polish Constitution of May 3rd, 1791 was the prelude to Poland's total loss of sovereignty and partition by Russia, Prussia and Austria, from 1795 to 1918.

BLACK KNIGHT
Polish hero of the Battle of Grunwald (1410), in which Poles and Lithuanians defeated the Teutonic Knights of the Cross.

VERNYHORA
Legendary 18th century Ukrainian bard and seer who foretold the destruction and resurrection of Poland.

SPECTRE
Jakub Szela, leader of the 1846 Polish peasant uprising in the Austrian "partition", against the property-owning gentry. Szela was given an Austrian decoration, hence the reference to his medal.

Stage Setting

November Night. The scene is the living room of a country farm-house. The walls are painted a greyish white, almost blue, so that both furniture and the characters as they appear are bathed in a single shade of grey-blue.

Through an open side-door, leading to the hall, can be heard the noise of a wedding celebration in full swing – booming basses, the shrill squeak of fiddles, a strident clarinet, the shouting of peasants – men and women – and, deadening all other sounds, the rhythmic swish and thump of the dancers' feet, as they swirl round the hall in a confused mass, to the beat of some song, barely audible in the hubbub...

The attention of the characters who pass through this room on-stage, is fixed throughout on the dance. Ears and eyes are ceaselessly attracted by the Polish melody... a dance of swirling colours glimpsed by the half-light of kitchen lamps – the multicoloured ribbons, peacock plumes, embroidered capes and the colourful coats, jackets and jerkins of rural fashion in Poland at the time.

In the rear wall, a door gives access to an alcove containing farmhouse beds and a cradle. Children lie asleep on the beds. Ranged above them, holy pictures. In the other side-wall of the room, a small window, with a muslin curtain, above which is a wreath of plaited corn. Outside, it is dusk. The window looks on to an orchard and a rose-bush swathed in straw to protect it from the winter weather.

In the centre of the room is a round table, covered with an ample white cloth, on which, alongside gleaming bronze Jewish candlesticks, are lots of plates and cutlery, abandoned in such disorder as to suggest that the whole throng of wedding-guests have only just eaten and made off, without bothering to tidy up. Round the table are a number of plain white-wooden kitchen chairs. The room also contains a writing-desk strewn with papers, above which hangs a photograph of Vernyhora,

as painted by Matejko, and a lithograph of Matejko's "Battle of Racławice".

Against the wall in the background is a worn, grey sofa over which hang crossed swords, flintlocks, belts and a sheepskin bag. In one corner stands a white stove and beside it an Empire table decorated with a few glittering bronze ornaments, as well as an old clock with alabaster columns supporting a gilded dial with a portrait of a beautiful woman in a dark dress, cut in the fashion of the 1840s. A light muslin turban surmounts her youthful face framed by ringlets.

Beside the door leading to the dance, stands a huge peasant-style chest, painted with variegated flowers and colourful designs. It looks worn and faded. Near the window, there is a battered old armchair with a high back.

Above the door which leads to the dance hangs an immense painting of Our Lady of Ostrobrama in her silver robe with gold trimmings on a sapphire blue background. Above the bedroom door, an equally large picture of Our Lady of Częstochowa in her variegated dress, wearing the beads and the Crown of Poland's Queen. She holds the Holy Child, whose hand is raised in blessing.

The ceiling is of wood with long, straight rafters inscribed with Anno Domini and the year of construction.

The action of the play takes place in 1900.

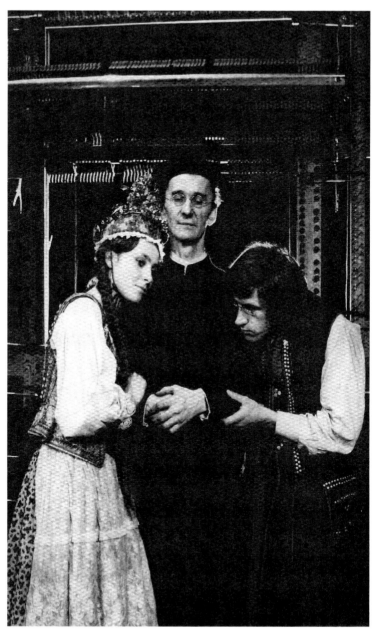

The Wedding, Stary Theatre, Cracow, 1977, directed and designed by Jerzy Grzegorzewski. A. Mandat as the Bride, B. Nowak as the Priest, and J. Radziwiłowicz as the Groom. Photographer: Zbigniew Łagocki

ACT ONE

SCENE 1

HEADMAN, JOURNALIST.

HEADMAN: So, what's new in politics, sir?
　　　　Haven't the Chinese answered yet?

JOURNALIST: You, too, farmer? Have a heart!
　　　　Chinese – Chinese, all day long!

HEADMAN: You're a politician!

JOURNALIST:　　　　　　　　Right!
　　　　I've had my quota – up to here! *(Appropriate gesture.)*

HEADMAN: It's interesting all the same –

JOURNALIST: Then read the papers, if you must!
　　　　I doubt you know where China is.

HEADMAN: I daresay it's a long way off;
　　　　but what you gents don't realise
　　　　is, peasant common sense can hit
　　　　the target, far away or no.
　　　　We read the papers, even here!
　　　　We know a thing or two –

JOURNALIST:　　　　　　　　What for?

HEADMAN: To bring us closer to the world.

JOURNALIST: I should have thought, for country folk,
　　　　your parish would be world enough!

HEADMAN: We've got people here who stayed
　　　　two whole years, sir, in Japan –
　　　　when they had a war out there.

JOURNALIST: All's quiet here; why should you care?
　　　　The whole damn world can take up arms,
　　　　provided Poland's countryside
　　　　remains at peace with no alarms.

HEADMAN: Afraid we might kick up a fuss?
 Behind our backs, you laugh at us;
 we peasants, though, if pushed too far,
 are not the ones to dodge a scrap!
 Głowacki was our kind of chap!
 As I see things, you gentlefolk
 might not have been so taken in,
 if you'd not lost your will to win!

SCENE 2

JOURNALIST, ZOSIA.

JOURNALIST: A little Cossack to the life –
 out of the saddle, you look sad!

ZOSIA: You're still the same flirtatious lad!

JOURNALIST: It's not an idle compliment –
 I cannot stifle what I feel.

ZOSIA: So long as you distinguish real
 emotion, from the parlour game
 you play with any pretty face.
 And in this instance –

JOURNALIST: It's your grace
 and charm that prompted what I said...
 I love the way you bow your head!

ZOSIA: You do? I must say I'm amazed
 to be so generously praised!
 A leading paper's editor,
 who knows the world, to stand before
 me, scanning me with eyes asquint,
 as though I were an aquatint!

JOURNALIST: A perfect, painted miniature!
 The colours life-like, fresh and bright,
 the draughtsman's hand supremely sure –
 the frame no less! It's all so... right!

ZOSIA: I see you're quite a connoisseur!

JOURNALIST: Why be angry? Where's the sin?

ZOSIA: You sing at me like Lohengrin
 as he serenades his swan!
 Since we can never be as one,
 what use is all this song and dance?

JOURNALIST: Let's say it's just exuberance
 engendered by the company...

SCENE 3

RADCZYNI, HANECZKA, ZOSIA.

HANECZKA: Dearest Auntie! Can't a girl – ?

RADCZYNI: Why, what ails you, precious pearl?

HANECZKA: *We* stand still, while others prance?
 It isn't fair! *We* want to dance!

RADCZYNI: One of the gentlemen, no doubt –

ZOSIA: No gentlemen we care about!

RADCZYNI: Why don't you dance together, then?

ZOSIA: We'd sooner join the bridegroom's men;
 they're wearing peacock plumes that tall –
 they sweep the ceiling of the hall.

RADCZYNI: But it's so crowded at a ball!

HANECZKA: I love being squeezed and thrown about!

RADCZYNI: What? Pushed and shoved this way and that?
 Till some young bully's temper flares
 and next thing, there's a free-for-all!
 That's not for you! Best stay with me!

ZOSIA: Oh, please! We'll be back presently.

RADCZYNI: What have you to celebrate?
 Your hair's a mess, girl! Set it straight!

ZOSIA: Once round the floor! We won't be late!

HANECZKA: But why is Auntie angry, pray?

> She's just being cruel – but not for long;
> I'll soothe her fury with a kiss!

RADCZYNI: Haneczka always gets her way:
 go on, then – dance your feet off, miss!

SCENE 4

RADCZYNI, KLIMINA.

KLIMINA: Lord be praised! Good evening, ma'am!

RADCZYNI: Good evening, mistress, praise the Lord!

KLIMINA: I'm Klimina. My late spouse
 was village headman.

RADCZYNI: I'm Radczyni –
 Councillor's wife from Cracow.

KLIMINA: Cracow, indeed! Have you a son?

RADCZYNI: He's in there dancing –

KLIMINA: He'll have fun!
 There's girls enough to catch his eye.

RADCZYNI: He somehow never seems to click.
 All he does is stand and gape.

KLIMINA: Men fear girls. I'll tell you why:
 with some, one dance is all you need
 and you're a father, no escape!

RADCZYNI: You have your ways, we have ours –
 up to each to use her powers!

KLIMINA: Just thought I'd have a word with mum –
 who'll rock the grandson, when they hatch!

RADCZYNI: You're not the bird to miss a crumb!
 You've barely eyed the latest batch
 before you've made my son a match!

KLIMINA: I've had my fun already, so,
 nowadays, I help the young instead;
 the population has to grow!
 I pair them off and see them wed...

SCENE 5

ZOSIA, KASPER.

ZOSIA: Bridesman, won't you dance with me?

KASPER: You're in a hurry, aren't you, miss?

ZOSIA: Into the circle –

KASPER: Round we go!
 You're a one for larks, I know,
 Kashka won't be sad to miss
 a dance or two –

ZOSIA: Kashka? Who's she?

KASPER: There, in the corner. Can you see?

ZOSIA: A bridesmaid?

KASPER: She's the number one –
 that's the girl I'm meant to marry.

ZOSIA: Round the floor – just once for fun!

KASPER: Certainly, but please don't worry
 if I hold you rather tight;
 Kashka – well, she's not so slight.

ZOSIA: You're in love with her, all right!

KASPER: You're a one for larks, I see!

ZOSIA: Round the floor, just once – with me!

SCENE 6

HANECZKA, JASIEK.

HANECZKA: If Jasiek would care to dance with me,
 I'd be glad to dance with him.

JASIEK: At your service, miss; I'm free –
 obedient to your every whim.

HANECZKA: Come along, then! Join the round,
 let's make merry – leap and bound!
 You're the groom's best man today.

JASIEK: There's no role I'd sooner play!

SCENE 7

RADCZYNI, KLIMINA.

RADCZYNI: How's it going on your farm?
 Is the sowing finished yet?

KLIMINA: We don't sow anything this late...

RADCZYNI: Er – did the harvest turn out well?

KLIMINA: Thank God – far as I could tell!

RADCZYNI: Harvest fails, what greater harm?
 Tragic, after so much toil!

KLIMINA: We always manage to get by.

RADCZYNI: You're looking well, at any rate.

KLIMINA: You, too, ma'am; you look quite spry.

RADCZYNI: Younger than your years, I'd say.

KLIMINA: Like mistletoe by Christmas Day!

RADCZYNI: Perhaps for you, it's not too late –

KLIMINA: What makes you think I'd want a mate?

SCENE 8

PRIEST, BRIDE, GROOM.

GROOM: Reverend Father, I implore –
 don't forget us when you go.

PRIEST: Some despise me... They'd deplore
 my peasant speech, my manners mock,
 look askance and send me packing.
 Here, no courtesy is lacking:
 I'm at home among my flock –
 all good Polish peasant stock.

GROOM: But, Reverend Father, presently
 you will wear a canon's cape –

PRIEST: I may be a deserving man
 but who knows how the Vatican
 will choose which shoulders it should drape?
 I s'pose I might just get a cape...

GROOM: Perhaps, should favoured glance be cast
 upon us by the Holy See,
 my fervent wish –

BRIDE: Say what they like,
 these higher-arkies are the devil!
 Stand your ground and make them grovel!

GROOM: My dear, the subject we're discussing's
 how the Church may dignify
 our Reverend Father, by and by...

BRIDE: Beg pardon, I misunderstood –

PRIEST: Naive and innocent – that's good!

SCENE 9

GROOM, BRIDE.

BRIDE: Now we're alone, let us discuss
 how our loving's going to be.

GROOM: Kissing's what you really like;
 you'll enjoy it, wait and see!

BRIDE: But since I've vowed myself to you
 and none can part us – you or me...

GROOM: Hearts may love without regret!
 Now you're mine – what joy! What bliss!
 More'n I ever thought or said!

BRIDE: It's what you wanted – so, you're wed!

GROOM: When I kiss, I close my eyes;
 open-eyed, I never kiss –
 your cheek's so soft! I never yet –

BRIDE: How the blood begins to rise!

GROOM: Kiss me, kiss me, harder, press!

 Let me drown in your caress –
 lips, eyes, forehead, crown above –

BRIDE: You're insatiable for love!

GROOM: Never, ever satisfied!
 Always been my joy and pride;
 I could kiss you ceaselessly –

BRIDE: That would be a gruelling task!
 Any wonder, need I ask,
 why you look so pale? Such zeal –

GROOM: Don't wish to boast, but can't conceal
 they gave me not a moment's rest –

BRIDE: Because you – ?

GROOM: No, twas they who pressed!

BRIDE: What disgraceful antics, sir!

GROOM: We are self-taught, as it were;
 others showed me how to play.
 You, I'll love my own sweet way –
 our way, that is –

BRIDE: From the heart:
 as you like it, let it be...

GROOM: For ever, you can count on me.
 You're all I crave – my wheat, my sun!

BRIDE: Now you're wed – go join the fun!

SCENE 10

POET, MARYNA.

POET: If only a certain girl would say –
 since she's mistress of her heart –
 straightforwardly, "I fancy you",
 the same as any country lass...

MARYNA: Are you implying I'm the lass
 to voice such feeling openly?

You're very cocksure! Bold as brass!

POET: That wasn't what I had in mind –
that's if I had a plan at all.
My words were just a tender call –
a gentle tap to wake your heart,
in hopes that I might overhear
a word about what course to steer
and how to strike a loving spark.

MARYNA: I'm sad to leave you in the dark:
my heart is far from being aflame!
Whoever wants to stake a claim,
will be hard put to make his mark;
I'm sad to leave you in the dark;
though cold my heart, it might ignite –

POET: Cupid's dart could strike a light –

MARYNA: Cupid's blind and can betray –

POET: Winged and fleet is Cupid's thought –

MARYNA: Many people claim as much!

POET: Yes, but claims can come to nought.

MARYNA: Claims don't lead the way to church.

POET: You'd have Cupid caged, beset –

MARYNA: Fox trapped –

POET: Butterfly in net –

MARYNA: Queen's Page at your beck and call –

POET: Marriage vows put paid to all...
Love less hidebound best befits!

MARYNA: Call it quits, then –

POET: Why say quits?
What's the point at issue? It's
as though I had offended you.

MARYNA: What is it you want? Explain!

POET: That lessons be not learned in vain.

MARYNA: Who's been learning?

POET: Mutually –
 me from you and you from me.

MARYNA: Any point in my being smart?

POET: None.

MARYNA: So?

POET: Art for sake of art.

MARYNA: Turning heads, great fun, no doubt!
 Go, practise all the arts you please,
 but not on me. I've opted out.

POET: Conversation of the sort
 with which young men and girls consort,
 provocative in tone –
 a chat with a reluctant maid,
 concerning love and Cupid's darts –
 can often lead to light being thrown
 on one, or both their hearts.
 Whispers breathed by some fair one,
 half in earnest, half in fun –
 must always be precisely weighed.

MARYNA: Half serious and half in jest,
 you're merely flirting, sir, at best.

POET: Not at all – and well you know it!

MARYNA: You're a poet, sir – a poet!
 Lyric notes assail my ear
 so much so, that for you I fear
 Cupid's fleet, haphazard dart
 could one day penetrate *your* heart.

POET: If I flirt as you attest –
 half in earnest, half in jest –
 then the style is all my own.
 No-one comes to any harm,
 no-one's hurt or left to groan.

That pink ribbon on your arm
doesn't mean you're marriage-prone.
Woman is a mystery.

MARYNA: A better speech I've yet to hear!

POET: Words, words, words – just words, my dear!

MARYNA: Utter nonsense! Well you know it –

POET: What an original idea!

MARYNA: You're a poet, sir – a poet!

SCENE 11

PRIEST, GROOM, BRIDE.

PRIEST: I'd like a word with you, young lady,
 as I drink to your young man.

BRIDE: What is it, Father? Is all well?

PRIEST: Maybe, only time will tell.
 Men are men and rarely sage;
 endless cases prove it's so.
 Men are men and will rampage
 till they settle down, with age.

BRIDE: Like what happens to sour milk.

PRIEST: You're both young, my bridal pair.
 Though today all things look fair,
 passion cools with time. Beware!

GROOM: Thank you, Father – that, we know.
 Have no fear; we've nought to dread!
 God took charge of us this morning;
 He will smoothe the way ahead.
 We were both at nuptial Mass,
 made our vows before the altar.

PRIEST: Yes, but best intentions falter –
 countless mishaps come to pass.
 Just as well, for information –

GROOM: Thank you, Father, for the warning.

BRIDE: I'd tear her limb from limb, the tart!

GROOM: Truly loves the jealous heart!

PRIEST: Like a coloured illustration...

SCENE 12

GROOM, BRIDE.

GROOM: Do you love me?

BRIDE: Maybe, maybe...
 Why keep asking what you know?

GROOM: My heart-beat's like a hammer-blow,
 throbbing head, confused inside:
 darling Jagu ! You are mine!

BRIDE: Yours I am, by God's design.
 Why act as though you're mystified?
 Why keep asking what you know!

GROOM: You, with golden heart aglow,
 child-wife, you could hardly guess
 how I feel heart's hammer-blow,
 seeing you in wedding-dress –
 tinsel gleaming on your crown.
 Vest embroidered, like a doll
 fresh-unpacked and taken down
 from the showcase. What a sight!
 Petticoats and frilly lace,
 pigtails bound in ribbons bright!
 To think you're mine, my very own,
 with such a smile to light your face!

BRIDE: My boots are pinching – I could groan!

GROOM: Take a squint, love? That's a shame!

BRIDE: What cobbler, worthy of the name..?

GROOM: Dance barefoot, then!

BRIDE: A decent bride?!

Scandalous! Impossible!

GROOM: Why suffer? Take them off, instead.

BRIDE: Who'd go bootless to be wed!?

SCENE 13

PRIEST, GROOM.

GROOM: Who and why – says: 'Thou shalt not?'

PRIEST: All depends who's after what.

GROOM: You keep an eye on everyone –

PRIEST: Men aren't all alike, my son;
 each has his private fish to fry.
 These little fishes, by and by,
 so small, so unassuming,
 together form a shoal of vast extent.

GROOM: Forbid us to your heart's content!
 Man's happiness is there for all.
 One simply mustn't miss the chance,
 but follow fortune's merry call
 and, heedless of rebuke, advance.

PRIEST: All very well, my son!
 Men are variously inclined:
 plenty seek and do not find.

SCENE 14

RADCZYNI, MARYNA.

RADCZYNI: The girls are in their seventh heaven,
 not a care –

MARYNA: It's wonderful!
 The way that Headman grabbed my waist,
 swept me off and showed me how!
 I saw the stars above, I swear,
 when he whisked me through the air,

> spinning madly as we raced.

RADCZYNI: The sweat's just pouring from your brow!
> Take care! You'll catch a fearful chill.

MARYNA: Yes – but I can't help reflecting:
> gold is gold and brass is brass!

RADCZYNI: Sit down and rest! Don't chatter, lass.

MARYNA: Can't help my thoughts; they won't stay still!

SCENE 15

MARYNA, POET.

POET: Your eyes shed an electric glow!

MARYNA: I'm overheated from the dance –

POET: And now you're dreaming of romance.
> Have you someone's heart in tow?

MARYNA: Even yours might fill the bill –

POET: Is cracking whips your special skill?

MARYNA: What do you mean? Why? Against whom?

POET: In general – unspecified –

MARYNA: Have you someone's heart in tow?
> You're good at kicking, given room!

POET: Someone special?

MARYNA: No, come, come!
> In general – unspecified –

POET: What for?

MARYNA: Nothing, never mind!

POET: Doesn't matter –

MARYNA: No more chatter

POET: It's a riddle –

MARYNA: Sphinx!

POET: Medusa!

MARYNA: Shouldn't be hard for you to guess
 how modern girls reject a loser;
 as readily as I dismiss
 my fantasy of bliss sublime
 as an awful waste of time!

POET: Zeus and God in heaven reside,
 at home together, side by side,
 while Psyche fondly pets the pair...
 Of others sleeping there on high,
 from hearsay, you may be aware,
 though so far not confirmed by eye.

MARYNA: All that is very hard to grasp,
 since so far not confirmed by eye.
 I shun those dizzy heights – so proud,
 so loud, so distant, wrapped in cloud.
 High-flown speculation such –
 of which one's apt to hear so much –
 distinguishes the high from low,
 major from minor, honours due:
 all very strange and very new –
 but that's the way they run the show...

POET: A better speech I've yet to hear!

MARYNA: Word, words, words – just words, my dear!

POET: Feelings registered in haste –
 pity they should go to waste!

MARYNA: Not at all – and well you know it!
 Do you think I really care?

POET: I see that you remember where
 you've stuck the tag once you bestow it,
 glued and pinned for constant wear.

MARYNA: Pity they should go to waste –
 feelings registered in haste!

Wyspiański

You're a poet, sir – a poet.

POET: That's my label – and I show it!

SCENE 16

ZOSIA, HANECZKA.

ZOSIA: I so much want to be in love,
 so very, very, very much!

HANECZKA: The band has such a lively beat,
 your heart can't help but leap and soar,
 though long you'll weep, my dear, before
 romancing will assuage its heat.
 Heart take comfort, heart be brave!
 Tears must flow! Beyond the grave,
 and not before, true love you'll meet.

ZOSIA: Does fate make mock of happiness,
 deluding us with sparks of joy
 that flicker out in bitterness
 and dawning hope at once destroy?

HANECZKA: First, suffering must come your way –
 much misery and painful smart –
 then, maybe you'll know joy some day,
 when pain enough has seared your heart.

ZOSIA: If destiny were my affair,
 where – what's her name? – Fortuna sits,
 I'd rip the Golden fleece to bits –
 give everyone on earth a share,
 not torture them till strength is spent,
 exhausted by that long, hard haul –
 each shackled to his plough. They'd all
 be free to love to heart's content,
 each dizzy with the joy untold
 of being enmeshed with threads of gold.

HANECZKA: What of the Parcae – ancient crones
 who wait with shears to snip the weave?

ZOSIA: If suffering for sin atones,
 that's maybe why love's forced to grieve –
 to punish sin, that's why they're sent
 to cut the precious filament...
 I want to fall in love so much!

HANECZKA: You'll sob your heart out while you search,
 weep and whimper, fret and faint,
 until they march you into church;
 thereafter – love without complaint!

ZOSIA: My feelings would be scorned by such:
 I hadn't that in mind – not yet!
 No, I want someone to appear
 who'll sweep me off my feet at once –
 to whom I, too, could give my heart –
 by equal passion both beset.
 You see the sort of man I want
 to love so, very, very much!

HANECZKA: *My* feelings would be scorned by such.
 First, one has to try it out:
 one needs to suffer, pain endure,
 to learn what love is all about.

ZOSIA: I'd prefer my way, for sure!

SCENE 17

GROOM, JEW.

GROOM: Here's Moishe come to join the spree

JEW: I'm rather shy of company –

GROOM: But aren't we friends? Why should you be?

JEW: It's just that we're the kind of friends
 who don't much care for one another.

GROOM: There are those who'd fleece a brother –
 some there are, who look askance –

JEW: Let them! But, when they're in need,

plenty of them call on me.

GROOM: Stuff to pawn?

JEW: Why, yes! Then butter wouldn't melt!
You've changed colours – brand-new pelt.
Tomorrow, you'll switch back again...

GROOM: It's the national peasant dress –

JEW: Flirting with nationalism, then?
Up to you; fashionable, yes –
or was –

GROOM: No, will be! Question's when?

JEW: If folk would bother others less,
the next time, they might just succeed.

GROOM: Now is the very time we need!

JEW: I fiddle, you play bass – agreed?

GROOM: You've played by coming to the ball!

JEW: My daughter has already told me
you are very musical –

GROOM: I'd hoped to see your Rachel here.

JEW: Most certainly she's on her way.
Better than sleep, I heard her say:
men – and a party atmosphere!
A cultured girl –

GROOM: I'm sure you're right –

JEW: She says that music's her delight.
Not married yet – a lively spark –
she could become a postal clerk.
My daughter, sir, is very bright;
bang up-to-date, I'd have you know –
A star –

GROOM: Then she's your satellite!

JEW: Loves reading! Every book in sight –

and just as good at kneading dough;
to the Vienna opera she's been!
At home, she keeps the linen clean;
knows modern writers off by heart,
plaits her hair in hemispheres,
the way Italian angels do –
A la –

GROOM: Botticelli? True?

JEW: You'd like to meet her, sir, perhaps?
to chat – ?

GROOM: I meant to seek her out;
called once, but she was not about.

JEW: She rather likes you poet-chaps.
She's even fond of peasants, too.
She'll give them anything on tick –
so generous, it makes me sick.
It really is exasperating;
often I feel quite torn apart.
Business is business; heart is heart!
Why go and wed a peasant girl?
No bright young ladies in your set?

GROOM: Mediocre, those I've met.
I like the Botticelli type,
but wouldn't choose to fill the land
with girls of that exclusive brand.

SCENE 18

GROOM, JEW, RACHEL.

RACHEL: Ah, *bonsoir!*

JEW: My daughter's here!

RACHEL: A little cloudlet helped me steer –
a wisp of mist, the breath of eve,
towards this cottage all agleam,
which, from afar, an ark did seem
amid the flood, with swamps around

and drunken peasants' merry sound.
This cosy cottage all agleam,
loud with music in the night,
to me, what more appealing sight,
an ark in some enchanted dream!
And so I'm here – if Pa allows...

JEW: Why shouldn't Rachel, too, carouse?
A Jew, I'm used to being reviled,
but her, at least, you must respect.
She's not ashamed to be my child.

GROOM: You've come to dance, miss, I expect.
If you're in search of company,
we'll clasp you to us, this dark night.
There's dancing here and fiddlers gay –
A pledge of hospitality.

SCENE 19

GROOM, RACHEL.

RACHEL: The whole *ensemble* – a fairyland!
Oh, this cottage loud with song,
as though by nightingales invaded. –
All those costumes, rainbow-shaded!

GROOM: You are right! As moths – persuaded
by a candle – louder sound.
Once there's light, they flock around.

RACHEL: Fluttering hither full of trust,
blindly, gaily, since they must,
never for a moment dreaming
that the candles' fiery rings
will incinerate their wings...

GROOM: No doubt you winged your own way here?

RACHEL: My thoughts were winged, as I drew near!
Knee-deep in mud, I trudged along,
from the tavern to the hall.
Oh, this manor loud with song!

Oh, this madly dancing crowd!
Surely you must feel a strong
urge to versify aloud,
changing this and adding that?

GROOM: What I feel is what I hear –
 the quiet, peaceful atmosphere:
 orchard, thatch, green grove and mead,
 furrows, harvest, rain and seed.
 Up to now my life's been spent
 crabbed by mouldy walls, cement:
 there, everything was old and drab –
 here, suddenly, all's young and bright.
 For me, life's charm has come to light:
 youth I breathe by day and night!
 I look around, my eyes devour
 this lovely, colourful array
 of sprightly, robust folk at play,
 though crude and clumsy in their way.
 My past is fading by the hour;
 sight and hearing tell me so.
 Some day, I'll write what now I know.
 I cleave the air and sense below
 the charm and beauty of the dance –
 as though on horseback, up I fly!
 Four weeks, since I wore shoes and I
 have never felt so fit and strong –
 shoeless, hatless, all day long –
 much free-er since I took a chance
 and gave up wearing underpants!

SCENE 20

GROOM, RACHEL, POET.

POET: Your good lady'd like a word,
 if you've a moment –

GROOM: Time I went
 and paid attention to my wife.

RACHEL: Perhaps a word of mild correction,
 with a nod in my direction...

POET: Just a trifle; no harm meant.

SCENE 21

RACHEL, POET.

RACHEL: So you will stay with me instead?

POET: You interest me, I must confess.

RACHEL: Then I'll watch out and not transgress.

POET: One can tell it at first glance –

RACHEL: You think so? Just like that! Mere chance?

POET: A lightning bolt!

RACHEL: Can go astray...

POET: My dear young lady, not today!
 Love, Cupid and his golden dart –

RACHEL: That idol – Cupid! Wicked boy
 who blindly swoops to seize his prey,
 screaming:
 I shall burn, destroy!

POET: Bellerophon rode bareback in his day...
 You're steeped in poetry, my dear;
 your Muse has but to let us hear
 a jingle and the sky's alight.

RACHEL: No doubt you think the end's in sight
 and I'm your little Love-god's prey!

POET: From tip to toe in every way,
 you're Galatea!

RACHEL: Me, a nymph?
 The selfsame words were said to me
 by a lawyer, I recall...

POET: You shouldn't denigrate a man
 because he works as hard –

RACHEL: – as lymph?
 The sort of dreary soul one meets
 who simply listens and repeats
 what someone else before him took
 from a poem or a book:
 not original at all...

POET: You like your compliments hand-picked.

RACHEL: As from flowers or apple-trees,
 clouds and sun or frogs and snakes –
 blooming orchards, tranquil lakes;
 all the poetry that hurtles
 through the air, by breezes borne,
 fresh with novelty each morn,
 phosphorising all in sight.
 What I feel is what you write –
 so –

POET: What is it you're really after?

RACHEL: Pleasure, honey, joy and laughter,
 sweets of love and passion's bliss,
 happiness –

POET: Free love, as well?

RACHEL: I dream about free love so often!

POET: Would Fortuna's heart might soften!
 She'd regret inflicting pain –

RACHEL: Then, I would never dream again!

SCENE 22

RADCZYNI, GROOM.

GROOM: If you want to marry, do!

RADCZYNI: One who nears the noonday shine
 had best make haste before decline.

Wyspiański

GROOM: Like one who yearns to gulp a spring
 and, marrying to slake his thirst,
 acts as though in exaltation...

RADCZYNI: Into the well you leap, feet first –

GROOM: I'll never sink, I'll not go down!

RADCZYNI: He who takes a wife must drown!

GROOM: Let him drown or burn, I say,
 so long as loud the fiddlers play
 to celebrate the wedding-day –
 so long as the musicians grind,
 and, brisk as hand-mills, leap and bound,
 let's have crashing, clashing, dashing,
 dancing, prancing, twist and twirl,
 fiddle squeal with slender string,
 tenderly enlivening;
 churn away like water-mill –
 the moon is full, the sky is still –
 roaring, hissing, let them swirl –
 let there be no end to sound,
 even should they doze while dancing
 mindless of the noise entrancing,
 cradled in their reverie.
 World of spells and magic charms –
 all men brothers in my arms –
 everyone best man to me.
 As this joyful feast attests,
 God would envy me my guests!
 Sleep and music are alluring
 when life's complex, past enduring;
 dreams provide a pleasant haven –
 music, sleep and fantasy.
 I'd buy a fiddler, just for me.
 Sleep! When life's complex, past enduring,
 only strength immense assuring –
 strength titanic, nothing less –
 man's survival in the stress
 of such a godforsaken mess –

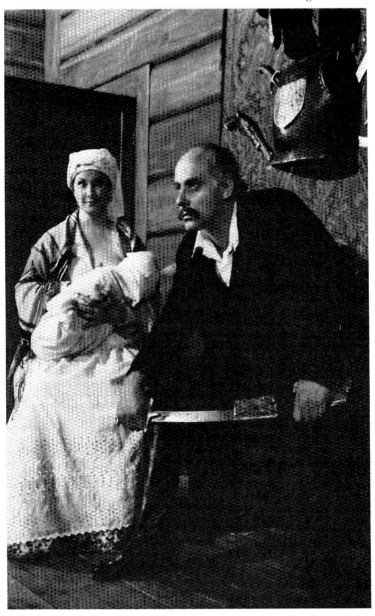

The Wedding, Stary Theatre, Cracow, 1989. Directed by Andrzej Wajda, with Tadeusz Huk as the Host and Anna Dymna as the Host's Wife. Photographer: Wojciech Plewiński

up to the neck and rising higher:
fate spells trouble; time hangs fire!
Music, sleep and fantasy...
I'd buy a fiddler just for me,
to charm my soul, set heart aglow!

RADCZYNI: On and on and on, you go!

SCENE 23

GROOM, POET.

GROOM: How are things? You're having fun?

POET: Never felt so young before!

GROOM: It seems to me, as I survey
the beauty and good luck of others,
that what's mine, I do not own.

POET: To worries such, a man is prone.
Whether good fortune's mine alone –
to hell with that! Not my affair –

GROOM: Easy does it, now! Take care!
When good fortune comes your way,
it's like discovering a tune –

POET: A poem?

GROOM: Impressions of the purest kind
are in the book of canticles;
the heart's whole trek is in the Psalter:
from earliest meetings of the mind,
to lengthy chats on country-walks –
in gardens, courtyard and, at last –
porch, hall, study, safely past –
talk of marriage, then the altar:
heart is home.

POET: It's curious
that what we understand by prose,
once recast in sound and rhyme,
can waft its content – mist sublime –

throughout the whole of literature.

GROOM: Just as in nature, to be sure,
 flowers may travel by their scent;
 and should they meet some malcontent,
 he'll smell the roses no less pure.

POET: Could one but deck oneself in roses,
 and bestride a mighty heap
 of fire-wood,
 thus to prove how man may sing,
 whose brow is crowned with roses,
 as he dies.

GROOM: Ah, one would need great Homer's lyre!

POET: Fate, atmosphere and fire,
 crimson flames from summit soar,
 heavy clouds of black smoke pour
 from the blazing pyre.

GROOM: Death!?

POET: Yes, Death – in Death is Power!

SCENE 24

POET, HOST.

POET: I sense the action of a drama,
 plangent, sinister, sedate –
 a polonaise! Grim panorama:
 captives groan and shackles grate,
 tempest shrills as we discover
 here, we have a noble lover –
 rugged hero, clad in armour,
 solid as a granite block –
 front-line knight of peerless stock,
 but – where love's concerned – a duffer!
 Quite a merry tale it is,
 but so very, very sad!

HOST: Each of us could call it his –

quite a merry tale it is,
but so very, very sad!

POET: An utter fantasy – quite mad!
One can see that right away,
gleaming armour, weapon-play;
past, yet close to present day.
Knight of old, in armour clad,
unafraid of any foe
save the spectre of his crime –
heart about to burst with woe.
Armour clad, his soul in hell,
he stops, enchanted, by a well,
peers into the turbid depths,
hoping water lies concealed,
scoops a handful but, no use,
dark and muddy is the yield.
Racked by thirst, he can't refuse,
laps the filthy dregs revealed.
Enchanted, by the well, but faint,
he stands there – like some Polish saint.

HOST: Dramatic! Lovely! Life is prone
to be all drama for us Poles –
playing grand, exalted roles.
One such hero need but groan –
and all of Poland wrings its hands;
every forest roars and rustles,
every mountain summit whistles,
but, I ask: who understands?

POET: Yes, knights errant are dramatic,
but you, too, are emblematic,
melancholy in your keep.
Empty castle where you sleep,
with all our simple folk around,
in the courtyard, at the gate –
one fine gentleman in state:
and these rugged, simple souls,
all this bold and knightly valour,

while God's rage, like thunder, rolls.

HOST: In all of us, it's welling up,
 everywhere, the storm is brewing;
 bolts of lightning are being hurled
 by figures from a bygone world,
 dressed in clothes of far-off days –
 but their ways are still our ways;
 thus, the past is on our side...
 Though memories may fade with time,
 in each of us, a storm is brewing.

POET: In each, the spirit's so forlorn,
 as even breath itself to scorn.
 The gallant heart would thither race,
 all its strength and courage brace
 for glorious deeds surpassing bold,
 but bleak reality croaks "Hold!"
 Reality takes us by surprise,
 invading mouth and ears and eyes;
 in each, the spirit, so dejected,
 longs to break away and leap –
 hands to plunge in blood, waist-deep –
 to throw its arms wide open, then,
 with mighty wings outspread, to soar
 where freedom is denied no more.
 But base reality is here,
 invading mouth and ears and eyes:
 distant now, what once seemed near.
 Heart so deeply buried lies,
 under furrowed layers of clay –
 all its spirit drained away.

HOST: Every year, the land is tilled,
 every year of every generation,
 time and again, a soul's revealed,
 greatness, once again, unsealed,
 then re-buried deep, in desperation.
 Time and again, a hero lifts his head
 to rise with mighty wings outspread –

> every year of every generation –
> only to fall and hope dismiss,
> as though engulfed by time's abyss;
> but each one lights a sacred flame –
> eternal glory to his name!

POET: It's like a curse upon us all,
 that holds us in a nightmare thrall.
 The heart is seized, our thoughts obsessed;
 imagination's yearning quest
 obscures our vision in a haze.
 Dreams alone delight our days.
 Our surroundings, we confuse;
 false perception misconstrues.
 Peasants we see as strong and bold,
 like the Piast kings of old.

HOST: But the peasant does have much
 in common with those Piasts – heaps!
 Ten years, I've lived here on the land,
 peasant neighbour close at hand...
 When he sows and ploughs and reaps,
 with what dignity, what zest!
 Peasants feel their task is blest,
 worth their care and interest.
 In church at prayer, no peasant sleeps –
 so dignified, so deep impressed!
 They're rulers in the way they act –
 there's power in peasants – that's a fact!

SCENE 25

POET, HOST, HEADMAN, FATHER.

HEADMAN: Blessings on you!

FATHER: God be praised!

HOST: Praise be, father – greetings, friend!
 Guests from Krakov here in force –

FATHER: It's all quite new to them, of course –

 for us – it's ancient history.
 They look at everything and gawp,
 as though it were a mystery.

HOST: If it's so new, the sight of it
 might help to wake them up a bit.

HEADMAN: You're from town – been here before.
 D'ye like the country less – or more?

POET: Why, here, I'm in my element!

HEADMAN: Country's nicer! Town's a bore!
 Poverty and discontent!
 Here, folks' souls are still alive:
 imagination can survive...

HOST: If that's your view –

HEADMAN: Between ourselves,
 should time and place and cause arise,
 we're not against, you realise?
 If someone needs our hands and helves,
 our scythes are hanging on the wall!

FATHER: You like talking big, that's all!

HEADMAN: Look at these fists and guess the punch!
 You ought to hear the way they whistle –
 hear the sound of rib-cage crunch!

HOST: Like with that Jew –

HEADMAN: Oh, as for him –
 I really did the scoundrel proud!
 I thought I'd knocked him out for good.
 He was just blinded by the blood –
 no room to fall in such a crowd.
 Election day it was, an' all –
 We cast our votes in Falcon Hall.
 That bastard was an infiltrator,
 bawling his head off! Agitator!
 I really did the scoundrel proud –
 I thought I'd knocked him out for good.

He was just blinded by the blood –
no room to fall in such a crowd!

HOST: Was Bird the fellow you elected?

HEADMAN: If Bird he be, then let him fly!

POET: Has this Bird of yours got wings?

HEADMAN: It isn't every bird that sings:
　　　men, too, vary quite a bit.
　　　One looks the next man in the eye:
　　　an eagle never lands in shit!
　　　We've different ways of seeing things,
　　　but if there's trouble, you can count
　　　on our being here, sir, at the ready –
　　　We're our own men – strong and steady.

POET: That's if someone's there to bow to!
　　　Find yourselves a Piast King!

HEADMAN: You needn't tell me twice, sir, how to –
　　　I'm a ploughman, that's the thing.
　　　I know a raven from a grub;
　　　I plough my furrow, that's the nub!

HOST: My brother travels far and wide.

HEADMAN: Pity that you don't decide
　　　to settle here; we've lovely rye.
　　　The wheat would surely be your pride.
　　　We'd see you wedded by and by...
　　　You'd have your patch, yourself in charge,
　　　small, but yours – well worth a try.

POET: I'm driven on from place to place –

HEADMAN: Where next?

FATHER:　　　　　　　You can't imagine why?
　　　This gentleman needs lots of space.

POET: I'm a crane, a bird of passage:
　　　I fly in when summer's near,
　　　build myself a nest of rose
　　　and straw collected from your thatch.

Perched on chimney-pot aloft,
I survey each field and croft.
Is a storm in sight? Who knows?
I feel new life, within me hidden,
spring, as from a grave or midden:
herbs of all sorts, which the lash
of blazing sun converts to ash –
and all on such a massive scale –
a graveyard painted by Ruisdael...
If somebody tries to pierce my heart,
the blade will shatter on a bone.
No cure for that by doctor's art,
must bear the pain with fortitude.
Man craves his suffering, to atone,
his pain will cherish – his alone!
He then seeks refuge overseas.
But once the heart has suffered pain,
pangs of grievance still remain,
which a man would gladly ease
in a bed of seething waves.
Sleep in the depths, or space he craves!
That's what goads me on my way;
I believe that pain is strength.

HEADMAN: Marry a country girl, old son:
Won't cost much and bags of fun!

HOST: Careful, headman! You're the one
who'd have to act as go-between!

HEADMAN: I'm all for helping folks who're keen
on drawing closer to each other:
lad and lass, then father, mother –
unity is strength, I mean...

HOST: Well said, Headman! Does you credit!

FATHER: What's all this? It's not polite
to bully him about being wed. It
wouldn't suit a crane in flight –

POET: A homing bird –

HEADMAN: A fly-by-night!

SCENE 26

FATHER, GRANDAD.

GRANDAD: Look at them, just look! You see
 the way that things are changing, eh?

FATHER: The good Lord gives; the good Lord takes!
 I never dreamt I'd see the day.

GRANDAD: Fine sight these townsfolk make! Alas,
 you can't get round the simple fact:
 there's a difference of class.

FATHER: Who cares for status – all that stuff?
 He fancies her and that's enough!
 We're all of us the same at heart.
 Alone, their men get bored and fuss –
 life's more fun when they're with us.

GRANDAD: Fun? Not always, take my word!
 Angry outbursts have occurred –
 even bloodshed. Throats were slit,
 peasant topcoats splashed with gore.

FATHER: Savagery, one must admit.
 Don't know, myself. My hands are clean.
 No doubt the devil was at work –
 eternal hell-fire lit that scene.
 Lead us not into temptation,
 holy Jesus, sweet and mild...
 You knew them –

GRANDAD: You were still a child,
 but I was there myself and saw –
 watched and saw with my own eyes –
 the blood-soaked snow begin to thaw;
 then saw the Spectre, Plague, arise.
 Waving a great black cloth, it strode
 and Death it sowed...

FATHER: Cholera! What a fearful crime!

GRANDAD: Hundreds were slaughtered at the time.
 Like wounded bitterns there they fell
 on field and dung-heap, all pell-mell!

FATHER: Eternal rest grant unto them –

GRANDAD: It did no good to cross yourself!
 their foreheads, as it were, ordained,
 were smudged with black and crimson-stained.
 An act of God – and butchery,
 to mark the Shrovetide revelry.

FATHER: You're like a raven, grandad! You'll
 blight the wedding with disaster!

GRANDAD: Mark my words, I'm not a fool:
 your grandson will be lord and master!

SCENE 27

GRANDAD, JEW.

GRANDAD: Here they dance and, there, carouse –

JEW: I must get the inn swept out,
 before the wedding feast is done.

GRANDAD: They'd dance as well in muck and mire!
 Here, nothing has been swept at all –
 it needs a Jew to take such care.

JEW: What's that you say? What do you mean?
 My daughter keeps our tavern clean.
 Why tarry here? There's service there!

GRANDAD: You're not a guest at this affair –

JEW: I've come on business, I admit.

GRANDAD: Touting custom for your inn?

JEW: The wedding's caused such fuss and din,
 that everyone's come flocking here.

GRANDAD: He's a townsman, she's a peasant.

That's brought townsfolk by the score;
all hobnobbing, what is more –

JEW: Quite a spectacle! How pleasant!
 Must have cost a tidy sum...
 Fancy them dancing here together –
 birds of so different a feather!

SCENE 28

JEW, PRIEST.

PRIEST: Inn-keeper, you won't forget?
 Tomorrow!

JEW: Yes, I know's, it's due.

PRIEST: And Moishe settles on the dot,
 which is why I stick with you.

JEW: Whatever else a Jew cannot,
 when it comes to money matters
 he can always be of use.

PRIEST: The peasants haven't got a bean;
 I don't sell to rags and tatters.

JEW: I take and pay –

PRIEST: I give and take.

JEW: My way, your way –

PRIEST: Each may choose:
 poor peasants I will not refuse.

JEW: Look at them, Father! You can see,
 how quickly peasants come to blows.
 The Headman's just split Matthew's skull!

PRIEST: His head is wooden, through and through.

JEW: Perhaps he didn't touch him, then;
 maybe his head just cracked in two.

PRIEST: No wonder they're so bellicose;
 whose vodka is it that they drink?

Jew, peasant, vodka – ancient link!

JEW: I sell it since I keep a shop.
 Tomorrow, Headman pays my bill;
 today, the scoundrel's trading blows.

PRIEST: To make you rich, you swell the till
 by stinging peasants through the nose.

JEW: So I should *lose* ? Just wait until
 I give you back your inn...

PRIEST: Time yet!

JEW: Time's money –

PRIEST: So's a sacred debt –
 Tomorrow, right?

JEW: Jews don't forget.

PRIEST: Speak to the Headman –

JEW: Sooner not!
 Can't reason with a drunken sot!...

SCENE 29

JEW, PRIEST, HEADMAN.

HEADMAN: Heard my name – whatsh trouble, then?

PRIEST: You, Headman, fighting yet again?

HEADMAN: Itsh all over, shorted out –
 took no time to knock him flat.

PRIEST: What do you think you're playing at –
 all these squabbles, fights and brawls?

HEADMAN: I'm quick-tempered and it galls
 me when some shcoundrel queers my pitch.

JEW: Headman, look, may I remind you –
 just in case it's slipped your mind, you
 bought my pony –

HEADMAN: Shon of a bitch!
 Your pony? Liar! Parashite!
 They suck our blood, they cheat on prices,
 ruin us with tricksh and vices –

PRIEST: Headman, you've a debt to meet –

HEADMAN: That pony – Shatan made me buy it –
 wasn't worth three kopecks – try it!
 I won't pay!

PRIEST: (*To JEW.*) You'll have to sue!

HEADMAN: (*To PRIEST.*)
 Your honour, itsh a damned disgrace!
 It'sh thanks to you and by your grace,
 that Moishe lords it in that pub!

PRIEST: But if you refuse to pay –

HEADMAN: You can flay me if you like!

JEW: Fact is that my rent's too high;
 You should lower it, reverend.

HEADMAN: (*Pointing at JEW.*)
 You've got to squeezh the likes of him –

PRIEST: Since the rent is fair, I must.

JEW: (*Pointing at HEADMAN.*)
 But *I* can't pay the priest unless
 You pay your debt!

PRIEST: (*To HEADMAN.) Pay* up!

HEADMAN: Bad cess!
 Who'sh stealing all my hard-earned pelf?
 The Jew or you, your reverend shelf?

PRIEST: Vodka!

JEW: Fetch your own!

HEADMAN: Be damned!
 Don't be angry, Father, please –
 when I'm roused, it's jusht that I'm –
 God help me! – capable of crime:

I'd even crush my brother'sh bones!

SCENE 30

GROOM, HOST.

GROOM: How they squabble, brawl and fight!

HOST: It's their tempers catch alight!
 Tempers flare and take command.
 Worse, if weapons are to hand;
 then they blaze as fierce as straw.
 Flash a knife – that's all they need
 neither God nor man to heed.
 As in forty-six – the devils!
 that was Polish peasantry!

GROOM: Indeed, a vile atrocity!

HOST: Still they boast about those revels.

GROOM: I only know from what I've heard;
 I'd sooner not let what occurred
 pollute my view of country-life.
 Some breed of mongrels, bent on strife
 poisoned rivers with their breath –
 in blood-soaked shirts, dispensing death.
 But look how peasants are today –

HOST: It happened once and who's to say –

GROOM: We've forgotten everything.
 They sawed my grandfather in two!
 We've forgotten everything.

HOST: They stabbed my father once or twice,
 pushed and beat him, black and blue
 with picks and hoes and cudgels, too –
 then chased him, bleeding, over ice...
 We've forgotten everything...

GROOM: How people change is past belief.
 The patterns history weaves are strange.
 We've forgotten everything:

 torture, evil, pain and grief;
 peacock-feathers in exchange!

HOST: Nature forces us to change;
 but folk still cling to their belief
 that something good will come about.
 Each year, carolling, we go out
 in search of alms and hope to see
 that something good will come about.
 Nature forces us to change:
 gale that blows for all its worth;
 a shudder in the womb of earth;
 the scent of crops we breathe as if,
 to drown in corn with every sniff.
 But though the soil be scant of yield,
 peasants cannot quit the field.
 For them, the ancient gods hold sway:
 still they cling to their belief.

GROOM: The patterns history weaves are strange.

HOST: Strange the patterns history weaves.

SCENE 31

HOST, PRIEST.

HOST: Reverend Father, off so soon?
 We'll get the horses right away.

PRIEST: Time passes very nicely here.
 What a homely atmosphere!
 Interesting pair, the newly-weds!

HOST: Interesting – yes – like everything.
 One for the road?

PRIEST: A stirrup-cup!

HOST: Kurdesh?

PRIEST: Old-Polish pick-me-up!

HOST: A finer one, you'll never sup!!

SCENE 32

HANECZKA, JASIEK.

HANECZKA: Thank you, Jasiu!

JASIEK: Was that fun?

HANECZKA: Lovely! Later – let's repeat!

JASIEK: Holding you was such a treat –
 like the image of a saint –
 or those Easter eggs they paint!

HANECZKA: I'll dance with you again, my sweet.

SCENE 33

KASPER, JASIEK.

KASPER: Jasiek, fellow-groomsman – here!
 A word in private, for your ear.
 Guess what –

JASIEK: No idea. What's that?

KASPER: I think they fancy us, those two –

JASIEK: Perhaps... I felt the same as you.
 Kasper, fellow-groomsman – here!
 A word in private, for your ear.
 Guess what –

KASPER: No idea. What now?

JASIEK: Could it just have been a tease?

KASPER: They are bridesmaids, if you please,
 and we're not worthless nobodies.

JASIEK: Brother, what we are – we are!

SCENE 34

JASIEK.

JASIEK: I got myself some peacock plumes,

Decked myself in peacock plumes,
What a lovely sight;
Though not mine by right,
They help to brighten up your rooms.

I'll seize your manor by and by –
That purse of gold that I espy –
And sprinkle golden coins before
The eyes of all the hungry poor,
And peacock plumes I'll buy.

SCENE 35

GROOM, RADCZYNI.

GROOM: Let them bark and bray! No matter!
　　　Is it really all that strange
　　　if I drink milk instead of water,
　　　won't pursue a girl who flees,
　　　nor waste time trying to woo a tease –
　　　or years of quarantine endure,
　　　while some young lady's making sure?

RADCZYNI: You can't make me change my view.

GROOM: Depends on how you look at things.
　　　A simple sideboard or a chair –
　　　shall we have it here or there? –
　　　can ignite a row between
　　　the fondest lovers ever seen.
　　　Two I knew – engaged five years –
　　　a sideboard forced to part in tears.

RADCZYNI: You can't make me change my view.

SCENE 36

POET, RACHEL.

POET: Might you one day fall in love
　　　with a peasant?

RACHEL: 　　　　　　　Prophesying?

They attract me, no denying!
He'd need to be a handsome lad –
back to nature and so on.

POET: Any peasant would be glad...
No knowing whom you'd pick upon.
Your father says it makes him sad
to see that you're so literary.

RACHEL: He denies me nothing, ever –
even boasts that I am clever.
Interesting, is it not?
Exploiters, traders, I and he?

POET: The whole thing's poetry to you:
business, father, peasants, too.

RACHEL: I've read an awful lot of verse.

POET: Written any?

RACHEL: No. I nurse
a grudge against this modern curse
of writing. It distresses me
when, everywhere I look, I see
the spell on living poetry cast
by poets dead, whose time is past.
From reading, pleasure I derive:
for me, the dead are still alive.

POET: Oh, let the dear departed be!
Muse in gardens full of roses,
clouds above, where fountains play –
you'd be better rubbing noses
with the poets of today!

RACHEL: You're always finding fault with me!
Nature's secrets, once forbidden,
from me, are now no longer hidden.

POET: Though night outside is black as ink,
desire inflames your heart, I think.
To bed, my dear, you'd sooner slink –
and not alone...

RACHEL: I just called by –
 the house was such a cheerful sight –
 the way a moth or butterfly
 is drawn by a lamp alight.
 But now discreetly I shall wend
 my way home.
 I'll imagine you tonight
 from afar.
 If I'm in love, then I shall send
 a letter to you – with my key.

POET: Then, ply between us, Poetry –
 our messenger from room to room –
 from garden, where the roses bloom
 to orchard where the fruit-trees sleep.
 They can just be seen from here.
 So, as you go your way, my dear,
 if your shawl should brush a shrub,
 then may your yearning sorrows seep
 into its winter livery
 and, in return, the sadness creep
 from shrouded bush, subconsciously,
 into your heart.

RACHEL: Ah yes, no doubt!

POET: Should you chance to meet a groomsman,
 could be, you'll be taken in –
 and sin.

RACHEL: I won't. You needn't worry!
 Garden first, then trees. I'll hurry.
 Stand and watch me from the window.

POET: Gladly. I'll observe you – tortured –
 wandering through that dreary orchard,
 like some soul astray in love –
 half-maid, half-angel, as you rub
 against a straw-protected shrub,
 like a painting by Burne-Jones –
 while I stand watching, safe and warm.

RACHEL: You needn't fear I'll come to harm.
 The sharpest frost no problem poses
 for one who breathes the scent of roses.
 You're straw-clad, as the shrubs are wrapped,
 till Spring arrives and you're uncapped
 and free to bloom at will.

POET: Oh, what a thrill!
 Do I sense peevish undertones?

RACHEL: Look at that rose-bush in the garden,
 clad in straw against the cold.
 Before that mannequin of straw
 I confess my poetry,
 admitting to the heresy
 that I've imbibed.
 How it's begun to gnaw and bite
 me, now I feel the pangs of love!
 That straw-man, I shall now invite
 indoors. I'll bid him join the spree!
 And you'll convince him, possibly,
 that Rachel always tells the truth.

POET: Rachel's what they call you, is it?

RACHEL: Whatever difference does that make?

POET: You're blushing? Why, for heaven's sake?
 I'm delighted with your name.
 Invite all guests that come to mind!
 That name is full of poetry –

RACHEL: It is pretty, I agree –
 Now hear me, if you'll be so kind,
 my love avow:
 for you, poetics most refined
 I want – and I shall tell you how:
 invite here to the wedding feast
 all wonders, flowers, shrubs and trees,
 the crash of thunder, melodies –

POET: And the Straw-man!

RACHEL: But, of course!
 It tickles you?
 Straw, withered rose and night,
 combined with supernatural Might.

POET: Some wedding party! Who would throw it
 on so generous a scale!

RACHEL: Adieu! For I must go. Don't fail!
 A moment's respite has to end!
 You've heard me out; now, you're a poet!

POET: You've put your shawl on. Must you go?
 Adieu, so soon?

RACHEL: Big parties aren't my style, you know.
 I only lingered
 pour passer le temps, my friend!

SCENE 37

POET, BRIDE.

POET: The bride herself! I've got a notion,
 all you wish, will come to pass.
 Love has set your cheeks aflame –

BRIDE: I've no learning to my name –
 knowing nothing's my vocation.

POET: By request and at your order,
 you're a bride today and merry –
 fair as jasmine, sweet as cherry.

BRIDE: I don't understand the reason
 why it is that you expect
 so much of me...

POET: You're so happy, bride-elect!
 Let your wedding-guests include
 those for whom misfortune's brewed
 an evil stew – and those distressed,
 by misery, by Hell oppressed –

whose spirits, though by fear beset,
crave their liberation yet.

BRIDE: Why conjure spirits out of Hell?

POET: Let them come, their tales to tell.
at the wedding-feast appear –

BRIDE: That could be quite a problem here!
Have we room for such a crowd?

POET: Music charms the time allowed –
spirits pause a moment only
then, like smoke, they disappear.

BRIDE: Sounds like nonsense, with respect!
Others may perhaps detect
what you're on about! My husband!

SCENE 38

POET, BRIDE, GROOM.

POET: Ah! The groom, himself! You're right!
Listen, since you are a poet,
feasting on your wedding-night –

GROOM: I'm so happy, I'd invite
the whole wide world to join the fun:
share my gladness, everyone!

POET: Then, invite that straw-man, please –
hiding there, among the trees!

GROOM: What a brain-wave! Ha, ha, ha!
Come in Straw-man,
Join the spree!
I, the groom, invite you in:
Straw-man, join the
Revelry!

BRIDE: We've so much food and so much drink,
he'll mock our gluttony, I think!

GROOM: Far too much for us, at least –
 Come in, Straw-man –
 Join the Feast!

BRIDE: Come along, if you've a mind!

POET: Ha, ha, ha!

BRIDE: Ha, ha, ha!
 As the strokes of midnight boom,
 Straw-man, join the bride and groom!

GROOM: Ha, ha, ha!

POET: Ha, ha, ha!

BRIDE: If he heard us he might come –
 Straw-men, though, are deaf and dumb.

GROOM: Bring any friends of yours you like:
 they're welcome all
 to join the Ball –

BRIDE: Come and share the celebration!

GROOM: Hope he heard our invitation!

End of Act One.

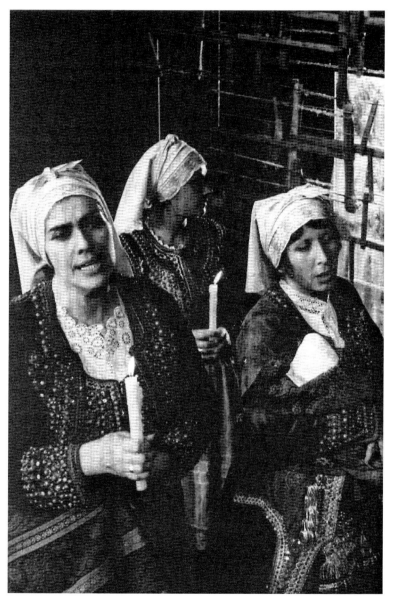

The Wedding, Stary Theatre, Cracow, 1977. Directed and designed by Jerzy Grzegorzewski, with W. Kruszewska as Klimina, E. Karkoszka as Marysia, and M. Zającówna-Radwan as the Host's Wife.
Photographer: Zbigniew Łagocki

ACT TWO

SCENE 1

WIFE, ISIA.

The candles have burnt out. Small kitchen lamp on table.

WIFE: Time all children were in bed!
 Midnight! Look sharp, sleepy-head!

ISIA: Couldn't sleep a wink, mama,
 with all this noise and tralala!
 Look, the babies are asleep.
 Leave them where they are. They'll keep!

WIFE: You come here!

ISIA: Oh, mummy, please!
 One more dance and then I'll go.
 The stove'll hide me, they won't know.

WIFE: Tomorrow, you'll be quite dead beat –
 I'll never get you on your feet –
 so into bed with you, my sweet!

ISIA: No, please, mama! I can't go yet!
 I'll miss the moment when they put
 the bonnet on her head for life
 to show that she's a proper wife!
 Please, ma, please – do let me stay!
 Just this once – today's the day!

WIFE: Your eyes are blinking, I can see –
 already half-asleep, my girl!

ISIA: Oh, if only I could be
 a grown-up! Watch them pin it on her –
 oh, those lucky maids of honour!

WIFE: Right, just bring that lantern here,
 then give the baby's crib a rock –
 and when you've done – this once, my dear,
 I'll let you watch, despite the clock!

SCENE 2

WIFE, ISIA, KLIMINA.

KLIMINA: (*In neighbouring room.*)
 Time to crown the bride, come on!
 Place the bonnet on her head:
 that's the sign she's truly wed!

*The two women light small tallow candles and holding the
flaming tapers in their hands, make their way to the ceremony.
For a short while following their exit, ISIA, alone, amuses
herself turning the wick of the lamp up and down and peering
into the light. The clock in the room strikes midnight.*

SCENE 3

ISIA, STRAW-MAN.

STRAW-MAN: Whoever called
 had something planned;
 I came in
 what I had to hand.
 Here I am and here I stand
 at the Wedding!
 Many guests
 this way are heading –
 at the wind's command...
 No matter what he has in mind
 or, in his dreams, may find –
 be he after
 sin or laughter,
 whether lord or down-and-out –
 welcome to the Wedding rout!

ISIA: Who *are* you? Gave me quite a turn!
 Looks like rubbish fit to burn!

STRAW-MAN: Tell your daddy this, my dear:
 guests are coming – guests galore –
 all the guests he wants – and more!

ISIA: As for you, best disappear!
 Horrid Straw-man, out you go!

Can't have litter here, you know!

STRAW-MAN: Tell your daddy, this, my dear –

ISIA: Back where you belong – out there!
 Stupid Straw-man! Don't you dare –

STRAW-MAN: Word to mum when next you speak –

ISIA: Clear off, can't you? What a cheek!

STRAW-MAN: Someone called me here tonight –
 must have had his reasons, right?

ISIA: Filthy Straw-man! Layabout!
 Out with you, I said! Get out!

STRAW-MAN: This suit's the only one I had –
 I got it from your own dear dad,
 because he feared, as winter neared
 and autumn winds blew chill,
 that being a rose-bush, I'd take ill.
 Yes, that's the way of it, m'dear!
 Where else could I have found this gear?

ISIA: Off with you! Get back outside!
 You're not fit to see the bride!

STRAW-MAN: Someone sent for me, tonight...
 Must have had some reason! Right?

SCENE 4

MARYSIA, WOJTEK.

MARYSIA: Wojtek, love, come take a rest,
 I'm tired of dancing, quite worn out.

WOJTEK: Dearest, what's this all about?
 Darling wife, I'm sad for you;
 stay on, won't you? Take the floor –
 enjoy yourself!

MARYSIA: No, thanks – no more –
 since I'd not be able to

dance with you.

WOJTEK: I suddenly came over queer –
 felt like *you* were getting married –
 (*Sings.*) "Mary, dear, it isn't ours –
 This is not our wedding-day!"

MARYSIA: Sit near the children, over there,
 a snooze will put you right as rain!

WOJTEK: Things went dark before my eyes,
 as I was going to'ards the band;
 strange black shapes appeared to rise,
 creeping up on us, I swear.

MARYSIA: Shadows on the wall, no doubt,
 cast by lamplight. There, you see
 how they flicker in and out.

WOJTEK: (*Sings.*) "Keep your eyes skinned, stable-boy;
 or Master'll steal your pride and joy..."
 Say no more about it, love!

MARYSIA: What's upset you?

WOJTEK: Mary, please!

 As the two of them retire to the alcove at the back, MARYSIA
 picks up the lamp from the table. The room is in darkness.
 Only the alcove is lit, apart from a strip of light through the
 door that leads to the dancing.

SCENE 5

MARYSIA, GHOST.

GHOST: I was to have married you –
 you, my bride-to-be.

MARYSIA: Betrothed the pair of us, that's true:
 you were pledged to me.

GHOST: For me, you were the sun's gold shine!
 My little house is chill –

Wyspiański

MARYSIA: You seem to breathe out frosty air –
 your clothes smell colder still...

GHOST: Your countenance is flushed and fair,
 the life-blood in your veins –

MARYSIA: I was to have married you –
 you were pledged to me.

GHOST: Mary, my betrothed, it's true –
 Long you filled my dreams.

MARYSIA: Where are you living now – today?
 You left for cities far away;
 I waited for you – oh, so long!
 But you, my love, were never there.
 You've come back at last, it seems.
 Where are you living? Tell me – where?

GHOST: I raced through cities far and wide
 in harum-scarum, carefree quest.
 At last, in earth I came to rest –
 food for maggots to digest.

MARYSIA: O my God, for pity's sake!
 Devoured by maggots... So you died?

GHOST: By echos from the Tatras lured,
 I've come back. I'm here, in fact,
 by village voices reassured.
 How once-familiar sounds attract,
 reminding one of early years!
 My home these days is – well – a grave;
 not that I'm that particular!
 Many a trial I've had to brave,
 but don't imagine, Mary dear,
 that I am just a corpse... No fear!
 A lively soul, I flit around.
 Listening out, I caught the sound
 of village voices – and was lured.

MARYSIA: Where's that grave of yours? Where is it?
 Sounds too far away to go –

not a place I'd ever visit.

She covers her eyes with her hand. He snatches it away abruptly.

GHOST: Tear-drops scald me as they flow.
 Damn my grave! I'm here beside you –
 I am yours! I've not denied you.
 Do you still recall the day
 when the pear-tree's shadow lay
 in that orchard at our feet,
 shielding us from noonday heat
 as we stood there, hand in hand?

MARYSIA: So many years, so long ago...

GHOST: Turn your head towards me, sweet!

MARYSIA: We stood together hand in hand.
 You sent a go-between, you know...

GHOST: So many years, so long ago.

MARYSIA: My wedding would have been as grand
 as this one here, today.

GHOST: Let's just have one dance before
 I vanish, on my way.

MARYSIA: Friends of yours are here... At least,
 stay a while –

GHOST: One dance, no more –
 after that, I must away:
 duty calls, I can't delay!

MARYSIA: But this, too, is *our* wedding-feast –
 once around the floor, just now –

GHOST: Oh, the sadness on your brow –

MARYSIA: Your breath is cold as winter night –

GHOST: Clasp me to your bosom tight,
 let me feel your hands, the glow –

MARYSIA: Don't clutch my ribbons! Please, let go!

The odour of a corpse clings so.

GHOST: Love me –

MARYSIA: Stop it! Don't come near!

GHOST: Why fend me off ? No need to fear.

MARYSIA: Your clothing reeks of earth and rime;
you're not for me; it's past the time.

GHOST: Duty calls me, I must go!
just one dance...

MARYSIA: No! Stop it! No!

SCENE 6

MARYSIA, WOJTEK.

WOJTEK: Mary, love – your cheeks are white –

MARYSIA: It's nothing – just the way the light
makes my face look –

WOJTEK: Shivering, too –

MARYSIA: Door was open and it blew
a gust of snow inside – no matter.

WOJTEK: Now you're flushed again – that's better!
Why?

MARYSIA: The way you look at me;
Wojtek, hug me to your chest –
you're the one I like the best!

WOJTEK: (*Sings.*) "Captive Mary, lend a hand
on my little patch of land."

SCENE 7

STAŃCZYK, JOURNALIST.

STAŃCZYK: (*Walking.*) Someone's walking close behind –

JOURNALIST: Someone's marching just ahead –

STAŃCZYK: (*Having just sat down.*)
　　　Peasant homestead, hut and shed:
　　　that's my Poland! Selfsame tears,
　　　same old crimes and dreams and fears,
　　　petty meanness, dirt and lies –
　　　well I know them – no surprise.

JOURNALIST: You're – ?

STAŃCZYK: 　　　　　　　A fool.

JOURNALIST: (*Recognising him.*) Great man, great mind!

STAŃCZYK: Great, because in motley gowned –
　　　great, because long lost to sight!
　　　More than ever, fools abound –
　　　enough to fill a parliament.
　　　Brother, hail!

JOURNALIST: 　　　　　Hail, Father Fool!
　　　The ranks of honest fools have slimmed.
　　　Our motley's dyed a dismal grey;
　　　the concept of one nation's dimmed –
　　　like those flares of yesterday
　　　which, bound to carriage linkman's wrist,
　　　once blazed the way ahead.
　　　The torches are but embers hot,
　　　though, strapped in place, they flicker still,
　　　burning the holders' hands who plot
　　　enchanted visions to fulfil.
　　　The nation's service would require
　　　whole regiments of noble fools,
　　　linkmen undeterred by fire,
　　　scorning pain with dying breath!
　　　The nation's candles are being snuffed –
　　　direst happenings befall;
　　　laughter and mockery are all
　　　that might yet rouse – perhaps inspire –
　　　a captive heart degraded, chained,
　　　yet still by Polish blood sustained.

STAŃCZYK: But you prefer to sleep?

JOURNALIST: What harm?
 I lull my own poor soul and calm
 my brother's restlessness as well.
 Makes no difference either way –
 good or bad, go or stay –
 terrible events befall.
 Things just happen, so it seems,
 far removed from all our dreams,
 alien in every way.
 Where we once excelled, we fail:
 all that was, is now no more:
 gone for good what went before.
 Third of May? A fairy-tale!
 Mother in her coffin lies,
 all her next-of-kin likewise,
 blessed and sprinkled by the priest.
 Sextons tamp the soil in place;
 survivors, glad to be released,
 revel at the funeral feast.
 Such merriment – a rank disgrace!
 Heavy drinking kills the soul
 but the heart it can't control.
 Heart in tears cries out the more,
 weeping at the church's door,
 bleeding at each holy shrine.
 Tortured still in cruel fashion,
 prodigal of warm compassion,
 heart proclaims, "The guilt is mine!"

STAŃCZYK: If a man confesses – fine!
 But the sins are someone else's;
 bucketfuls of tears he weeps,
 soul and heart are drenched in blood;
 although, from what he has to tell,
 it's clear he's – reasonably – well.
 Tomorrow, he'll be feeling good.
 I could weep most bitterly,

recounting someone else's crime,
spotting beams in neighbours' eyes,
sins and squalor, dirt and lies;
publicly make full confession
of my neighbour's least transgression!
That would be a farce sublime!
What priest could grant me absolution
from another sinner's crime?

JOURNALIST: Father's sins the son inherits,
worthless men breed worthless young:
none of whom salvation merits.
Each and every one's aware
that, for the chains our land must bear,
his cursed hand the guilt must share.
Twixt soul and body, disaccord
yawns like an everlasting gap
which grips the weak, as in a trap –
a monstrous, two-edged battle-sword.
We are weaklings. Greatness moulders,
bowed by curses on its shoulders,
weight of crimes and funeral palls.
The blood-stained shirt of Nessus galls;
greatness is criminal, pettiness – vile!
How is our Will today dispensed?
For Sorcery's evil hand, meanwhile,
Our land has fenced.

STAŃCZYK: Tears in style!
Grief so great for others' woes!?
Why adopt the cares of those
long since dead? Do you suppose
corpses you can resurrect, –
dust them down and newly decked –
lead them under your command
to some Last Supper in the land,
there to eat a dish so rare,
none but a poisoner could prepare,
lap it up and swill the lot
with a draught to speed the rot!

Must it be your blood they drink?!

JOURNALIST: *My* blood – ? Don't know what to think!
Sea-gulls screech in headlong chase,
high above the cliff-tops race.
Hear their melancholy cries,
haunting, full of grief –
out at sea, beyond the reef.
Ocean calm, sky overcast,
but no sign of hurricane:
total silence, emptiness...
Straining wings, with steady beat,
the gulls press onward, no retreat –
knowing that, where they are bound,
they will seek a perch in vain.
Faithful to their curse, they fly –
none dare pause, league after league,
spitting blood from sheer fatigue.
When at last they plunge from sight,
not a tear to mourn their plight:
death's a welcome, restful haven.

STAŃCZYK: As you speak, thus spoke the raven:
all you hear's the tolling bell,
commemorating those who fell.
Haven't you heard the belfry ring
with joy? Nor mighty Zygmunt sing?

JOURNALIST: Zygmunt, Zygmunt...

STAŃCZYK: The King's own bell!
Once at the royal feet I sat,
the court behind me, daughters, sons,
Italian Queen, monks, priests and nuns,
chanting plaintive benisons –
when suddenly the bell was rung
and everyone at once looked up.
Aloft, great Zygmunt swung and swung
and from the tower his voice rang out –
flying, floating all around
cradled in the upper air –

the very clouds were made aware;
and every head was bowed, devout.
I looked at the King –
and the King's face shone
as Zygmunt thundered – on and on.

JOURNALIST: Today, that voice still booms above
as we bury those we love –
calls us, urging us to come
and listen to the church's hum
amid the maze of addled wits
and the mighty groan of prayer;
that royal bell's our master! Its
ceaseless clangour fills the air
with a broken-hearted song –
our anthem. Poised upon the brink,
I know no path, nor what to think.

STAŃCZYK: You could slice my heart in two,
and nothing you would find inside
save that from which you shrink:
ignominy and disgrace,
burning shame, at most!
Our Fates would drive us into
the abyss –

JOURNALIST: But you're a ghost!

STAŃCZYK: I'm Shame!
Worse than Dante's, my inferno –
Hell alive.

JOURNALIST: I live in hell!

STAŃCZYK: Together into the abyss!

JOURNALIST: Togetherness!
Of all the torments that most gall:
buffoonery and ridicule
by us – the poorest wits of all!
"Together" – just a lot of kitsch,
"Together" – pride of newly rich,

"Together" – is a peasant's clout
"Together" – is some flashy bitch –
folly and superman-ity;
besides all that inanity –
a broken, bleeding heart.

STAŃCZYK: You sir, for your part,
like all the finest gabbers – claim
descent from trees which in my time
were in their prime.

JOURNALIST: I'd prefer a hundred-fold
my days were numbered now,
to this eternal rush and race
to chasm, abyss and turn-about.
No more flights that presage rout!
Each battle of the heart I face,
only to plunge on rocks age-old,
upon my lips the dying vow:
no more flights that presage rout!
Let everything be burned to ash,
ground to dust and blown away –
like columns shattered as they crash.
Let us drop dead of poisoned meats
at the funeral wake, I pray;
let everything be swept away:
those Polish fast-days to exalt
the names of poets sanctified –
rainbows of sentiment to vault
the desert wastes of crucified;
those folklore virgins wearing crowns –
and all Beliefs along with them!
Calamity! I cry.

STAŃCZYK: Ill-omened bird!

JOURNALIST: Calamity! Perhaps that word
will force us to emit a cry
peculiar to ourselves –
this generation's own.
Conscience! Conscience! we'll intone.

Truths we've had in rich supply –
truths – or poets' gems of mirth?
On Poland's frontiers we stand,
a futile presence in our land –
toys, whose talents rate our worth.

STAŃCZYK: Ill-omened bird!
The lure of card-play you preferred,
or else in woman's hot embrace
to quell your spirit with a swoon!
Spurred by an instant's heat, you race
blindly to your own cremation.
Then, the winds get up and soon
blow the ashes to damnation!
Abyss and chasm safely walled,
the shrieks and groans that once appalled
now seem a comic aberration,
of no account and nothing but
a self-consuming farce that feeds
upon its evil-smelling gut!
I know well how the spirit pines,
when sharp nails penetrate the heart
or one's own body feels the scourge.
Spit on crime! Ill-will revile!
But do not desecrate those shrines!
They had to play their sacred part.
No, do not desecrate the shrines:
that's vile!

JOURNALIST: Tragedian!

STAŃCZYK: Comedian!
You've earned the staff and bells!

JOURNALIST: They're yours to cherish, Father Fool!
You only know the *status quo*:
from you, all fools and jesters flow.

STAŃCZYK: Here's your paddle! Off you go!
Steer the Ship of Fools astray!
Your Polish staff of office, sir,
muddy the waters with it! Stir!

JOURNALIST: It's Satan's fault we lose our way:
at every cross-roads, pause, then err!
This is my cross-roads, here and now,
and you – my Satan, Demon, Fiend!
By shared buffoonery convened,
my soul in your direction leaned
before its fire was dead.
But now I scent the grave ahead,
the stench of leprosy.

STAŃCZYK: Rule, sir!
Accept the Polish herald's staff
and stir the waters with it. Stir!

JOURNALIST: Enough of that! My spirit's fled!
My heart was young once, long ago,
and that young heart of mine you stole.
With poison you infused my blood;
I see no roads to left or right –
God has robbed me of my sight.

STAŃCZYK: The Fates are pressing, pressing hard –
Greatness – Nothingness – hollow bell,
downcast heart.
You have struck a jesting knell:
that's *my* art.
The lying heart deceives them all:
best join the ball!
Seize the staff of office, pray!
and govern, sir!
Stir the waters with it, stir!
To the Wedding! To the Wedding!
Leap and prance!
Stir the nation's mixing-bowl;
poison hearts and heads let roll!
To the Wedding! To the Wedding!
Lead the dance!!!

SCENE 8

JOURNALIST, POET.

JOURNALIST: Man may perhaps escape the dregs,
 be spared from hunger's searing pain;
 but I am crippled, arms and legs –
 my every day's a hellish strain.
 Would Youth could snatch me from this trench,
 choked with mould and fungus stench!
 But Youth's now very far away,
 although it seems but yesterday!

POET: Why such a sudden blaze of grief?
 What miracle has changed you so?

JOURNALIST: A ghost appeared to me just now –
 a bitter giant of long ago –
 who thrust his herald's staff on me.

POET: Reflection's useful, I agree,
 but why such anguish, such distress?

JOURNALIST: My sense of utter worthlessness!
 I have been tortured mentally,
 dragged in shackles, forced to clank
 along the beaten track to rank!
 But I despise it all. I spit
 contempt, like any honest soul
 yet cannot cast my chains aside:
 restraints meanwhile are multiplied;
 I'm vexed by everything I hear:
 friendship? Pity? Farce and Lies!
 Yet people talk of friends as dear.
 Love's a farce!
 Yet love's half-whispers reach my ear.
 Honesty lies. The guests appear.
 Music is played – true Polish chords;
 upon the walls, I see crossed swords,
 icons, scenes from Poland's past.
 It pains me, irks me, I'm enraged.

What right have we to all of this?!
Have we the right to be alive?
We butterflies and crickets caged
grow fatter, for we seem to thrive
upon the poison we are fed.
We see the fate that lies ahead
and at the rotting corpse connive.

POET: The band's at fault if you're downcast:
conjuring visions of the past.
Gets on your nerves –

JOURNALIST: and no mistake! –
on nerves that hold the soul in thrall.
Those tunes of theirs, without a break,
made me think my soul had fled
and all about me radiance shed...

POET: Made you think? Your phrase implies
it proved one more illusion...

JOURNALIST: O Poetry! Siesta's peace!
You seek to calm, enslave, anaesthetise:
no heated words to spread confusion.
But don't dissemble, don't pretend:
you're in the fire yourself, my friend –
your tranquil mask's a sham!
That music calls to mind the drone
of bees communing in a hive.
We sound more like hornets!
Turns my stomach, all this show
of national merry-making! Joys
which, with the hubbub, rush and noise,
Cause me excruciating pain!

POET: Give me your hand.

JOURNALIST: Leave me alone –
I'll step outside. Across the plain,
The wind is blowing air, fresh air...

POET: Give me your hand –

JOURNALIST: Leave me alone!

SCENE 9

POET, KNIGHT.

POET: The vaults are now wide open thrown
 and yielding up their dead.
 With noise, confusion, whirl and fuss,
 the dead are coming back to us.
 Some force has rent the graves they've fled:
 I hear a voice cry out:

KNIGHT: Give me your hand!

POET: Let go!

KNIGHT: You're mine!

POET: Let go!

KNIGHT: You're mine!

POET: With iron hand he greets,
 and iron shields his brow –

KNIGHT: Look sharp, you wingèd bird!
 To horse, you laggard – now!
 Banish the curse and torture of defeats!

POET: Appalling shade, what's that you say?
 To horse? – Where? – Why – and how?
 Your armour chimes, funereal toll:
 your iron handshake grips my soul!

KNIGHT: To horse! Wake up, you beardless wight!
 Up and away! Like a bird, take flight!
 Tied to my saddle –

POET: – by a noose.

KNIGHT: You'll know me when I pull it tight;
 you are my prisoner, my slave.
 I take by force; for I am Power:
 behind me and before me wave
 the flags of fire.

Along all roads I ride, at sight,
trees, like candles, catch alight
and shafts of lightning pierce the night.
As we fly above the earth,
strain your ears for all they're worth!

POET: Let go! May darkness you devour!
My hands! My hands have gone quite numb!

KNIGHT: You're mine!

POET: Begone!

KNIGHT: You hear the thunder!

POET: Fit to shake the house asunder!

KNIGHT: Do you know who you're meant to be –
the sense of your dreams and fantasy?

POET: Dreams and visions, spectral wraith –

KNIGHT: Tomorrow dawns the day! Have faith!
Do you know what you might have been?

POET: Tell me!

KNIGHT: Harbinger – herald, rather!

POET: The voice: my visions' foster-father?
Spectre-Knight, phantasmal shade,
In earthly garb you've dressed your soul –

KNIGHT: Blood I demand, a bloody toll!
This happy night, I've reached my goal;
with gale-winds sobbing their alarms,
gifts I bear – the gift of arms.

POET: From the far realm of dreams returned –

KNIGHT: The ends of the earth, the dust of ages,
lands where fires unceasing burned –
on through caverns, dungeons, cages –
in my hunter's tireless quest,
gifts I bear – the gift of arms!

POET: With gale-winds sobbing their alarms,

you rise from dungeon, dust and rock –

KNIGHT: Hear my voice and reel with shock:
 I fought at Grunwald, notched my sword
 vanquishing the Teuton horde.
 The wind it blew, it howled and screamed
 soldiers' bodies, corpses teemed
 while the blood in rivers flowed!
 Giants forged that victory –
 turning point in history.
 Arms and armour on that field
 in gleaming hillocks stand revealed,
 iron mail and shattered spears,
 whose shafts were buried to the hilt,
 barricades of bodies built,
 funeral pyres in readiness
 for sacrifice.
 Thither hasten! Come, let's fly!
 We'll gather weapons from that store,
 spear and sabre, shield, escutcheon –
 stand there mid the blood until
 dawn – advancing in pale dudgeon –
 rouses all with mighty roar:
 the dead arise,
 their armour don,
 seize their spears and soldier on!
 Quick! In heaps the corpses wait!
 I've slid the cover from my tomb:
 high time I rose! It's getting late!

POET: Tears prick my eyes, but I can't see
 what this has got to do with me...

KNIGHT: Armed fury is the gift I bear.

POET: Your breath is cold, sepulchral air...

KNIGHT: Face me squarely, swear an oath:
 pledge your soul and body both.

POET: Behind your visor, dust and mould!
 Your eyes – black caves – no day behold.

> Behind your visor, only Night;
> your armour's hollow clank sounds haunted.

KNIGHT: My sword, my sword, is strength undaunted!
 Face me squarely, look at me!
 You know me?

POET: You are – ?

KNIGHT: I am Might!

POET: Visor up!

KNIGHT: Give me your hand!

POET: Take my soul!

KNIGHT: What do you see?

POET: Death, death – – – and Night!

SCENE 10

POET, GROOM.

POET: Power, Power age-old, eternal –
 Might invincible!

GROOM: What's that?

POET: I've been the most infernal
 idiot, I see. Far better burn all
 my futile works – mere shadow-plays!
 Now, everything is suddenly ablaze –
 hills and hearts one fiery hiss.
 I seem to hear, somewhere on high,
 boulders crashing from the sky
 and rumbling into an abyss.

GROOM: Sonnet – or ode – will you be writing?

POET: Neither! Something more exciting;
 I've felt the noose about my neck!
 Great is Poland's cause! No place
 for matters trivial or base!
 Instead, the sacred words uniting

on our coat of arms let's trace –
and eagles' wings attach thereto;
hussars' winged shoulder-straps relace
and don;
some great man then will show his face –
a Polish saint, as like as not!

GROOM: Fantastic!

POET: So, you like the plot?

GROOM: You'd something grander, then, in mind
than a poem?

POET: Visions of a warmer kind –
at this moment burning still –
still – but maybe only till
tomorrow, when the blazing walls
collapse! I long to tread that Hell!
Ah!

GROOM: Flushed with triumph!

POET: Hell on earth!
This manor, this enchanted cot –
Hell – white-hot!

GROOM: Whaaat!?

SCENE 11

GROOM, HETMAN, CHORUS.

CHORUS: Hetman Branecki, hey! Why so averse?
You'll surely spare us a copper!
Give us a kiss to remember you by –
a ducat, we're sure, you will not deny!
Come, sir, open your purse!

HETMAN: Ha, demons of Satan, Muscovite staff;
you know your master; take your gold!
Take it and welcome, if that's your need;
for me, this lodging's hell indeed.
Hurrah! You and I are agreed!

CHORUS: Hurrah! We're all in league with you!
Let's stay and dance the whole night through.
Give us a kiss to remember you by!
Don't pretend your pocket's bare –
with Moscow's gold you've cash to spare!
Hey, there Hetman! Hey, Branecki!

HETMAN: Take the gold, it's burning me!

CHORUS: Muscovite money burns, you say...

HETMAN: For me, this lodging's hell today!
The demons are quaffing my blood –
they tear my breast, my shoulders flay.
A filthy sight! The fiends at play –
disputing my guts in the mud!

GROOM: Hetman Branecki! Voivoda!

HETMAN: Let go of me! Have mercy!

GROOM: Sweet Jesus!

SCENE 12

GROOM, HETMAN.

HETMAN: Ha! The devils have disappeared;
somebody took pity on me.
But this wound is agony!
I waste no time on vain regrets;
a man like me, of hell-born breed,
scoffs at wounds and lets them bleed.
A century I've roamed the wilds,
primeval forest, hill and dale,
fallow fields and pastures neat –
my temples pulsing with the heat,
hammers pounding in my heart –
how my innards, burn and smart!
Tell your band to play for me!
Tell them Hell will pay for me!
This realm's a quarter in my grasp
yet someone only needs to gasp

"Jesus" – and, for a while, I'm free.
The air of earth refreshes me:
with every breath, I fill my chest!
Here, take this gold! Don't need the rest;
and keep the purse as well –
the demons ordered me to bring it.
Every evening, they renew my credit –
those four black-clad devil's minions –
singing "Branecki, you're in Hell!"
Lapping my life-blood as they shed it!
Yours to keep!

Hands him the purse.

GROOM: Hetman Branecki, Commander-in-Chief –
a scoundrel through and through,
though the King himself was fond of you.
You were the leader who misled us
into today's captivity!
No leaders now – rags, rubble, scum;
the nation's soul is frozen numb:
yours – seared by everlasting flame!
Now nothing can restore our name –
neither king nor suffering,
weeping, wailing or lament –
Hetman, this day was heaven-sent:
a day of love – my wedding-day!

HETMAN: You've hooked yourself a village slut?
Riff-raff – the Poles, if truth be told,
though they see their land as gold!
Better the Czarina's bastard daughters,
if you felt you had to rut:
I did well by being that bold!
Don't mourn for Poland, my dear sir –
you're gentry – "one of us", if you prefer:
you're free to choose!

GROOM: The devil take you! Blast your cheek!

HETMAN: If you were armed, you'd not dare speak!

SCENE 13

GROOM, HETMAN, CHORUS.

HETMAN: Hell-hounds pursue me – snap and bite!

CHORUS: You're cursed for all time – day and night!

HETMAN: Lift up your hearts! My own's been gored,
 torn from its moorings, rent apart!

CHORUS: You sold your country, Lion-heart!
 A flood of gold was your reward!
 O wedding guest, by gold obsessed,
 time to dance! Go, join the rest!

HETMAN: The gold, it scalds like boiling tar:
 Sursum corda ! *Vive le Tsar* !

CHORUS: Burning coals his face shall scar;
 groping fingers tear his guts –

HETMAN: Drink my blood from a thousand cuts –
 Shred my carcase! Do your worst!

CHORUS: Wedding guest by gold obsessed!
 Time to dance! Go, join the rest!
 Death's cavorting at the revel.
 Pearls by the gallon, gold galore:
 you sold your country to the Devil.

HETMAN: Moscow blood-hounds, slake your thirst:
 Sursum corda! Vive le Tsar!

CHORUS: Yoicks! Yoicks! View halloo!
 Join the merry dancers, do!
 Golden man! Wedding man!

SCENE 14

GROOM, GRANDAD.

GROOM: That nightmare lasted far too long:
 quite horrible, a hellish jape!

GRANDAD: What's the matter? What's gone wrong?
 Your young woman cast a spell?

GROOM: I saw devils out of Hell;
 they dragged a man in front of me!
 Air! Can't breathe! (*Running away.*)

GRANDAD: Why run away?

SCENE 15

GRANDAD, SPECTRE.

GRANDAD: (*Calling after the GROOM.*)
 I only meant to wish you well:
 a blessing on your wedding-day!

SPECTRE: Listen, friend. One moment, pray!

GRANDAD: Who? Get out, you blood-soaked pest!

SPECTRE: I'm invited... I'm a guest!
 Fetch a bowl of water please –
 give me hands and face a sluice
 I like these here festivities:
 drink and dance, you know – cut loose.

GRANDAD: Be off with you, you filthy wretch!

SPECTRE: Bowl of water, brother – please!
 Give me hands and face a sluice.

GRANDAD: Blood-stained clothes and blood-soaked hair!

SPECTRE: No need to keep repeating it –
 Heaven above is well aware:
 (*Sings.*) "Twas on the Shrovetide holiday".

GRANDAD: Be off with you, I said – you wretch!

SPECTRE: No call to yell at me that way –
 we're brother peasants after all;
 I'm Szela – come to join the ball!
 In forty-six, we slew their dads –
 Now, our daughters woo their lads!

> All togged out in Sunday best!
> Fetch a bowl of water, please –
> give me face and hands a sluice,
> you won't know me, once I'm spruce.
> I love these here festivities –
> drinking, dancing, cutting loose –
> it's just this mark upon me brow...

GRANDAD: Plague on you!

SPECTRE: Pestilence, the tomb –

GRANDAD: Get out, you corpse! You smack of doom!

SPECTRE: You see me medal's in its place?

GRANDAD: Your feet are ruining the floor!

SPECTRE: It's only blood; I'll swab the gore.
> Fetch me water, brother, please –
> bowl – so's I can wash me face;
> you won't know me, once I'm clean!

GRANDAD: Mary curse him – Heaven's Queen!

SPECTRE: Was ever seen a man so mean?
> Surely you can bring a pail
> of water so's to wash me gob?
> I'll not wait here to no avail.
> To the Wedding! To the Wedding!
> Let's go dance and join the mob!

SCENE 16

KASPER, KASIA, JASIEK.

JASIEK: Kasiu!

KASPER: Kasiu!

KASIA: What now, Jasiu?

JASIEK: Well, you know – it's plain enough –
> I quite like you – well, a bit...

KASPER: Kasiu, this way – over here:
 want to whisper –

KASIA: No more bluff!

KASPER: Make your mind up, which of us –

KASIA: The garden will be damp with dew –

KASPER: But if we went there together –

JASIEK: Kasper, you go down the barn –

KASIA: What for? Why there?

KASPER: Come on, you know –
 You go first – and heap the straw!

KASIA: Got to change first –

JASIEK: Why so slow?
 You glued together – ?

KASPER: Good as wed –

JASIEK: Her? Wed the first-come dunderhead
 who grabs her waist and whisks her round?

KASPER: Grabbing Kasia's well worthwhile!

JASIEK: Didn't have the urge myself;
 all the same, I felt attracted –

KASIA: Fetch some vodka –

KASPER: Here's the cash –

JASIEK: Now you're talking! That's the style!
 I'll dash!

SCENE 17

KASPER, KASIA.

KASIA: Just a joke! I'm not that rash!

KASPER: Come on, Kasia – for a lark –
 Let's go outside together, dear!

KASIA: The garden's drenched with dew and dark –
 Want to kiss me? Why not here?

KASPER: It's just that out there, in the park –
 it's a nicer atmosphere.

KASIA: Isn't that nice now, Kaspy, eh?
 Don't you –

KASPER: Yes, I do!

KASIA: Well?

KASPER: Still –

KASIA: Oh dear! My ribbon's given way –

KASPER: Did your bodice tear?

KASIA: Not there!
 The waistband of my petticoat –

KASPER: Wherever, Kasia, we may be –
 your fair cheeks will burn for me!
 (*Sings.*) But don't forbid me, love, today;
 tomorrow, you can go your way.

SCENE 18

NOS (With bottle and glass.), KASPER, KASIA.

NOS: Good health to both of you!

KASPER: And yours!

NOS: Just let me give the girl a buss!

KASPER: Good health!

KASIA: And thanks from both of us!

NOS: Now kiss me of your own free will!

KASIA: What cheek!

NOS: Afraid you'll suffer ill?
 Why pout? No need to fear a rash –
 we're clean-shaven, no moustache!
 If you want him, I permit you –

 but that halo doesn't fit you!

KASIA: Clear off! Whoever heard the like?
 Barely here and wants the lot!

NOS: If not, so what? There, I quit you.

KASPER: Full of vodka, drunken sot!

SCENE 19

BRIDE, GROOM.

BRIDE: My love, I'm done for – danced my fill
 but I'm afraid tomorrow still
 I'll feel I should have danced some more.
 Today, just like the day before,
 I danced till I was almost ill –
 nothing I need a doctor for –
 simply dancing...

GROOM: Just like rosary beads advancing,
 dances follow one by one –
 regular –
 The chain of dances, once begun,
 links dawn to dusk, three nights and days.

BRIDE: Until we satisfy the craze
 for merrymaking, song and dance –

GROOM: Kiss now or you'll regret the chance –

BRIDE: That's what you and I like best –

GROOM: Just wait till we enjoy the rest!

BRIDE: What bliss!

GROOM: We'll have a house like this –
 a sturdy manor built of larch –
 and I'll plant birch-trees all around.

BRIDE: Birches shoot up awful quick –
 three years, we'll have a shady screen –

GROOM: And there we'll sit amid the green,

there, we'll sit in the month of May
with the fruit-trees blossoming –

BRIDE: Fit for a king!

GROOM: (*Sings.*) And when it's fine and sunny weather,
Fine and sunny weather –

BRIDE: (*Sings.*) In the garden let's go gather –
Violets together!

SCENE 20

JOURNALIST, ZOSIA.

ZOSIA: Aaaah!

JOURNALIST: Aaaah!

ZOSIA: So dark!

JOURNALIST: Can't see a stem!

ZOSIA: I'm so weary, whirling round and round.

JOURNALIST: The peasantry have lost their charm?

ZOSIA: It isn't that; I look on them
no differently from you and me.

JOURNALIST: They still arouse your sympathy?

ZOSIA: I look and put my heart to bed.
with nice uplifting thoughts.
What use? I might as well, it's clear
attack a brick wall with my head!
To see so much contempt being shed
on all that's noble, good and dear
pains me.

JOURNALIST: But it's pain that passes.

ZOSIA: With your daily rag to mop each tear,
all pains pass –

JOURNALIST: They're epidemic...

ZOSIA: Don't you believe the unforeseen.
The motherland's not academic!

 Once committed, then the heart
 is dynamite.

JOURNALIST: A splendid start!
 One more turn around the floor
 and you'll be schooled for life!

ZOSIA: I'd never make a peasant's wife –
 nobody'll ask to marry me;
 but, Master Editor, I hope,
 within our rustic ball-room's scope –
 half-lit by glow of kitchen lamp –
 my dancing may just help a bit?

JOURNALIST: Since you, ma'am, deign to mention it.

ZOSIA: What brings *you* here then, by your leave?

JOURNALIST: I look, see, like, but don't believe –
 except in you –

ZOSIA: How so? Why me?

JOURNALIST: Your face, your eyes, the things you say –

ZOSIA: You like me, do you?

JOURNALIST: In a way...

SCENE 21

POET, RACHEL.

POET: Ah, you're back again. Come in!

RACHEL: I follow, faithful as your shadow.
 Laugh – but strange as it may appear –
 I had a feeling something odd
 was about to happen here.

POET: It's possible... Just now, outside –
 from some way off – I took you for
 a phantom, radiant in the dark.

RACHEL: This shawl was wrapped around me tight;
 lamp-light shining through the door.

POET: Eye-sight plays strange tricks at night.

RACHEL: Just now, I got a frightful scare –
turned back, because I didn't dare
go on, when somebody or other
stepped across my path.

POET: There's many a local old wives' tale –

RACHEL: – that comes alive in such a gale...
The wind is howling. Look, do you see –
like a hurricane advancing –
whistling, shrieking, shaking trees?

POET: It certainly shook the windows! Look,
there's something missing in the garden...

RACHEL: It's very dark out there.

POET: The rose-bush! Why, it's been uprooted!

RACHEL: What? Our rose that was straw-suited?

POET: Yes, our Straw-man –

RACHEL: He's been broken?
There was something that we wanted
from him – what?

POET: We were enchanted
by the spell of poetry! Still
this house vibrates with poetry!
The air is thick with feathers culled
from every known breed of bird:
the clash of spirits at Grunwald,
eagle, goose and peacock quill –
hussar and king we'll see alive –
swarming here, as to a hive.

RACHEL: There's been a change of atmosphere;
the house is deep in love, it's clear,
with Polishness – as well befits:
an ardour that imbues the soul
and burns as fierce as flax when it's
exposed to air.

POET: I never dreamt so much, I swear,
 until this evening, till tonight –

RACHEL: Oh, this weird, this eerie Might!
 Conflicting powers – gale that shrieks,
 primeval force –

POET: From Tatran peaks,
 memories fly back to me –
 of wings! To soar above that density
 of stone and forest –

RACHEL: To the summits –

POET: Like Valkyries!

RACHEL: Dreams today –
 after this sleepless night –
 will wondrous be, for watching eyes
 are filled with teeming shapes
 not easy to erase...

POET: Let's go and watch!

SCENE 22

HOST, KUBA.

KUBA: Some gentleman or other's just
 dismounted in the yard –
 riding a huge grey charger!

HOST: Take his horse,
 with Staszek, to the stable
 and see that it gets fed.

KUBA: From top to toe, all dressed in red –
 must be some great personage –
 grey-beard – lyre on saddle-bow –
 like those beggars at the fair
 with lyres adangle at the waist.
 Will Master meet him in the hall?

HOST: The house is chock-a-block with guests
 invited to the wedding ball!

> Some stranger curious to know
> what's happening? Fetch a light!

KUBA: I swear,
> in all my life, I never saw
> such a Pole –

HOST: You've not seen much!
> Even today there's plenty such:
> honest Poles who look the part!

KUBA: If so, they've all been hiding – where?
> We'll have the lantern in a tick –
> it's just we've got to trim the wick.

SCENE 23

HOST, WIFE, KUBA.

HOST: Hear that? We've got one more to house –
> sounds like some important guest.

WIFE: Shut that door! Can't stand the row!
> I've had my fill; I need a rest!
> Why play the domineering spouse?
> I can tell you're none too steady!

HOST: Let's not start to quarrel now!
> This wedding's trial enough already...
> He's not just anyone... You'll see!

WIFE: Shut the door! Can't stand that row!

HOST: Who the devil could it be?

SCENE 24

HOST, VERNYHORA.

VERNYHORA: Greetings, sir, accept my blessing!
> I have come here as your guest.

HOST: I wish your Honour peace and rest!
> Please excuse my wife; she's dressing.

VERNYHORA: Never mind, sir; time is pressing!

HOST: She's busy with a wife's affairs;
 an unexpected guest, I said.
 The fact is, she was at her prayers –
 having got the child to bed.

VERNYHORA: Don't trouble her; it's for the best –

HOST: Since she'd got the babe tucked in –
 and *they* were making such a din...
 It *is* a wedding after all –
 folks are bound to prance and spin –
 she thought she'd take a little rest.

VERNYHORA: Don't disturb your lady, please,
 by all means let them celebrate!
 Just you sit down and take your ease;
 I've many tidings to relate:
 we shall discuss affairs of state.

HOST: Yes, your Grace, why not indeed?

VERNYHORA: Sit –

HOST: I shall, most honoured guest;
 make yourself at home! No need
 for further ceremony. Rest!

VERNYHORA: From distant borne, I rode post-haste
 astride my mount –

HOST: A filthy night!
 by all the fallen fiends, you race
 here – for the first time – you alight?
 Who lured you out on such a night?
 By all the fallen fiends, your Grace –
 to drop in unexpectedly,
 in darkness, on a wedding-feast,
 suggests great urgency.

VERNYHORA: From far away, I travelled near
 and picked upon this wedding-feast,
 because you're all together here.
 I chose your Honour's residence

for decent folk, without pretence.

HOST: And so Your Grace arrived nearby;
nor was his instinct led astray:
we're simple people, as you say.

VERNYHORA: From far away, I chanced nearby
and barely spoke your name when I
was shown where your manor stood
by sturdy peasants, brave and good.

HOST: Open-hearted, frank and free,
they came to me and told me all:
among the things their tongues let fall,
that you were old, grandfatherly,
with silver beard and lyre complete.

VERNYHORA: This ancient, with his beard of rime,
was youthful, once upon a time!
You are simple folk and humble:
no great wrongs to make you grumble?
All you need to live and eat?

HOST: No golden harvest – corn or wheat!
Fields once golden, choked with weeds –
marsh and mire where once grew seeds!
Peaceful orchards – flower and fruit –
each in turn, they follow suit;
golden yield? Not on your life!
In vain these days you'd scour the land
for what lay once so close at hand.
I'd like your Grace to meet my wife...

VERNYHORA: No more golden harvests, true –
yet you're still quite young at heart,
simple folk you are and humble,
no great wrongs to make you grumble!
Maybe your wife has work to do?

HOST: In her room, just getting dressed.
I know she'll want to look her best
to greet the unexpected guest!
Presently, she'll serve some beer.

VERNYHORA: Stay, good sir, I must protest;
 I've special cause to catch your ear.

HOST: Easier talking with a drink –
 whether the topic's ships or shoes,
 a tipple helps, I always think.

VERNYHORA: Provided I'm not going to lose
 the chance to catch your private ear.
 I want a confidential chat –
 just us –

HOST: Your Grace may count on that!
 This is the moment! Now you're here,
 permit me to inquire your name...

VERNYHORA: Not known to you?

HOST: (*Searching memory.*) Someone I know...
 Someone sincere, well-loved, although –
 somehow menacing – ancient, old –
 a century –

VERNYHORA: A tale long told –

HOST: Known... but unexpected... (*Failing to guess.*) No!

VERNYHORA: Have you forgotten church-bells tolling,
 skies ablaze and thunder rolling –
 bloody slaughter, streams of gore – ?

HOST: Some kind of dream, a dream of yore?
 Yes, I seem to hear those bells –
 mixed with the music of the dance,
 legends, tales of high romance.

VERNYHORA: Still I hear those tolling bells,
 above the sound of wedding dance!
 A solemn, tortured groan that swells
 like the blood of victims shed:
 I was there. I saw the dead.
 Evermore I hear those bells.
 I watched the martyred bodies fall
 abused, reviled by one and all –

damned amid the shouts and yells
as fathers stood and cursed their sons
and sons their fathers cursed no less –
Gethsamene of bitterness!
Tears of blood, tormented tears,
reverberating down the years,
as the bells' wild clamour swells;
still I hear those tolling bells.

HOST: Bygone days and times long past –
a distant dream that did not last.
Groans now suffocate the dance,
legends, tales of high romance.

VERNYHORA: Amid the fiery afterglow,
I sat my charger battle-shod,
waiting for a sign from God.
And, from the clouds, for all below,
shafts of lightning lit the sky.

HOST: So far-off seeming, yet, close by.
Someone I know – yet unexpected,
someone who yesterday was more a
figment of dreams and fantasies:
beard and lyre... it's...

VERNYHORA: Vernyhora!

HOST: Of course! Who else but Vernyhora!
Beard and lyre – you're known, expected –
you, who yesterday were more a
figment of dreams and fantasies –
like all our old celebrities:
you gallop here on your grey charger,
straight to my front door – with tidings!

VERNYHORA: With the Word!

HOST: You've brought the Word!

VERNYHORA: The Order!

HOST: Word of command, no less?
To heart long since in readiness,

roused by those thunder-bolts you heard.

VERNYHORA: Order and word of command, no less –
to hearts alert in readiness!
Listen with care, my friend, for we –
in this grave moment of decision,
the Covenant must now agree.

HOST: It's like a living dream, a vision –
time of life-and-death decision!
What's the order?

VERNYHORA: Three commands!

HOST: So great this moment of decision,
I am challenged to the core.

VERNYHORA: Send runners out ere break of day;
fetch every district councillor!

HOST: It's like a dream with life's precision –
they're mostly here beneath my roof,
dancing to the wedding-band.

VERNYHORA: What once was hid, we'll soon display;
what once was far is now at hand.
Thanks to the wedding which you planned,
most are gathered neath your roof;
but heralds send, ere break of day,
to north and south, to east and west.

HOST: The riders I'll dispatch tonight,
and call to arms ere break of day!
I'll seek my wife's advice – that's best;
her peasant wit shall have its say.

VERNYHORA: Send them north, south, east and west!
Be ready, ere the sky is light.
Once you've sent your envoys – right!
Let all outside the church parade,
that every simple, sturdy soul
may understand our worthy goal.
In God's name, greet the cavalcade

and forbid them make a sound:
no clash of blade or harness rattle,
kneeling, as before a battle!
Let each man, in the hush profound,
strain his ears for noise of hoof
approaching on the Cracow road –

HOST: I'll strain my ears for sound of hoof –

VERNYHORA: I know! Your zeal's beyond reproof –
yes, horses on the Cracow road;
they'll hear the clatter of my hoof,
see the Archangel's flag displayed!

HOST: I'll strain my ears to hear that hoof,
but, brave or not beyond reproof,
may I know your grand design?

VERNYHORA: Blind obedience, faith divine;
I know your valour needs no proof!

HOST: Outside the church, then, I parade?
It's the fulfillment of a vision!
Who conferred on me such honour?
First to hear – the chosen one
at this moment of decision!

VERNYHORA: Be ready ere the dawn you see!

HOST: Scythe-blades rising with the sun!
I'll be ready –

VERNYHORA: Do you swear?

HOST: I've said so –

VERNYHORA: Swear it!

HOST: Life's begun!
Be you a spectre in the air,
or a phantom from the grave,
raised by magic out of dust –
you've spoken ancient words of trust,
persuading me all doubts to waive.
What I had secretly in mind,

you have voiced as though a fact –
in vivid detail and exact.

VERNYHORA: The Word I speak, indeed, is fact;
the hour is grave, the hour is grave...
your wedding-feast *I* chose today –
your home, your path, this farm of yours.
Listen how the wind is howling –
downpour fit to fill a lake,
huge trees clash and branches swing,
shrubs and bushes shudder, shake;
out there, my retainers sing,
while a thousand horses beat
frozen earth with gold-shod feet.

HOST: Jesus, mercy, I entreat!

VERNYHORA: He who reaches Warsaw first
flags aflutter, troops athirst,
under Mary's blessed shield –
who, summoning district headmen all,
before them, in the Sejm shall stand –
he shall save our Motherland!

HOST: A vivid picture, so exact!
The miracle your Grace has planned
already sounds accomplished fact!

VERNYHORA: All is sacred, for the best:
I travelled far; as I came near,
I chose your home, your property –
and your wedding-party's cheer!
May your leadership be blest:
to you, I pass the Golden Horn!

HOST: The Golden Horn!?

VERNYHORA: To use for rallying the others.

HOST: My band of brothers!

VERNYHORA: With the sound of its chivalrous clarion,
strength is reborn;
fate it defies with the courage to carry on:

yours is the Horn!

HOST: Thanks be to God!

VERNYHORA: The heralds you, sir, must dispatch;
 outside the church, then, all parade.

HOST: Once they're together on the spot,
 do they discuss? And – if so – what?

VERNYHORA: The secret must not be betrayed!
 At dawn, let everybody meet –
 but *no* discussion! I repeat:
 in total silence, let them wait.
 Secrecy must be complete!
 Rise very early – don't be late –
 and, at the glimmer of first light
 scan the roads for sound or sight!

HOST: At dawn?

VERNYHORA: At dawn!

HOST: God bless our might!

SCENE 25

HOST, WIFE.

HOST: Listen, darling wife! I say –
 it's getting late!

WIFE: What's wrong with you?

HOST: This is a special day – today!
 I've suddenly heard something new.

WIFE: Good or bad? I need a clue!

HOST: Sorry, that will have to do.
 My head is buzzing, can't say more;
 you'd never guess what lies in store!

WIFE: What *is* all this? What's up with you?
 Are you sick? Who *was* that man?

HOST: That old man was – Vernyhora!

But you mustn't breathe a word:
I've told you, but you haven't heard!
He came in strictest secrecy.

WIFE: Where's he gone – ?

HOST: He's ridden off...
He said some most important things.
Gather arms –

WIFE: Are you all there?

HOST: My knapsack, cartridges... my sash...
My shot-gun and my pistols, too;
swords as well; I'll take the pair!

WIFE: O Jesus! Has there been a clash?
At night? Where this time? Who or which?

HOST: I must be ready!

WIFE: Fight? Not you!
You can barely stand! You're sick!

HOST: I've got to ride at once, tonight –

WIFE: *You* ride? You'll wind up in a ditch!

HOST: I swore an oath – before first light,
ride I must –

WIFE: You lunatic!
Ghosts and wizards!?

HOST: It's no trick!
Life begins for us today!

WIFE: Lord save us from the Fiend, I pray!

HOST: Far he rode till he was near –
envoy, herald – Vernyhora!
Already, some great plan's been laid –
miles he rode to find me here –
that's the long and short of it.
He commanded, I obey.
I've sworn an oath! No more to say.
His strength bewitched me, truth to tell –

115

the nation's Spirit!

WIFE: Fiend from Hell!
By all that's holy – you are sick!
Who, what, where – you've not replied.
You're drunk!

HOST: The Spirit is our guide!

SCENE 26

HOST, JASIEK.

HOST: Jasiek!!

JASIEK: Sir?

HOST: Here!

JASIEK: What's amiss?

HOST: Saddle your nag, prepare to ride!
You've got to rouse the countryside!

JASIEK: Me! Ride out? What – now!?

HOST: To horse!

JASIEK: I'll get lost in this abyss –
bogs and marshes! Slip and slide!

HOST: Nonsense, Jasiek! You'll fly through!

JASIEK: I'll have to get the horse untied!

HOST: You must! Great things at stake!

JASIEK: For us?

HOST: At the gallop! Far and wide –
knock on windows, shout "Get up!"
Before day breaks, I want to find
all peasants stood outside the church,
bearing arms of every kind!

JASIEK: Scythes, you mean? Our sacred rights!

HOST: We can do with swords as well!

JASIEK: There speaks a warrior who fights!

HOST: Our sacred rights!

JASIEK: At break-neck speed!

HOST: It's secret!

JASIEK: Peasants with scythes, you say?
 The wind will bear me on my way!

HOST: They must be here by dawn!

JASIEK: Agreed!

HOST: If Satan tempts you, pay no heed –
 Ride on – !

JASIEK: I'll give him stormy weather!

HOST: Before the dew is on the heather,
 or the birds commence their song –

JASIEK: I'll have flown –

HOST: Swift and strong!

JASIEK: What's *this* ?

HOST: (*Hands JASIEK the Golden Horn received from
 VERNYHORA.*) To keep you safe from harm –

JASIEK: Pure gold!

HOST: Don't lose it! That's a charm!
 Hang the horn around your neck
 and sound it with almighty blast
 at cross-roads, as you gallop past –
 against all spells, by demons cast.
 Don't dismount, whoever orders –
 Gallop on –

JASIEK: To Poland's borders!

HOST: Before the cock crows thrice, be back!
 Once you're here – immediately –
 blow the horn with utmost might
 and all our spirits will ignite

as never in a century!
Then wait the coming of first light:
but do not lose that Golden Horn –
God's own gift to those forlorn!

JASIEK: Sooner roast in Hell at dawn!

HOST: Unless that golden voice shall ring,
the whole affair will go awry!

JASIEK: I'll hang it round –

HOST: Don't break the sling!

JASIEK: I'm off!

HOST: Cracovian hero – fly!

JASIEK runs out but returns, bending down to pick up his cap from the floor.

JASIEK: My peacock feathers! Must look nice!

HOST: Be back before the cock crows thrice!

SCENE 27

HOST, STASZEK.

STASZEK: What's the news, sir? What's afoot?
Whoever felt such wind as blew
when that old man took leave of you!

HOST: You brought that stranger to my door –
in crimson, fur-lined coat and sash.

STASZEK: I never saw his like before,
he'd sparks of gold on his moustache!
As for that scarlet coat of his,
twas like a fire, sir, furnace-bright –
his horse! A devil! Fearsome sight!

HOST: The horse was grey, caparisoned,
with multicoloured weave and frond.

STASZEK: Two pistols on his saddle slung –

HOST: A lyre, as well, from saddle hung –

STASZEK: The sort of thing you might have seen –

HOST: Somewhere, once... can't quite recall –

STASZEK: I stood beside that horse an' all,
 when suddenly its tail it swung –
 a mighty swish – I heard a sob –
 it swiped young Kuba in the gob!

HOST: Kuba held him?

STASZEK: Take my word,
 impossible to get a grip!
 That tail was cracking like a whip.
 We dragged the snaffle, not a hope –
 until the old man reappeared, got up –

HOST: And rode away.

STASZEK: A magic feat!
 As the rider took his seat,
 coals inside the horse caught light.
 It farted fire and blazing bright,
 free at last to make a dash,
 gave us both a parting slash.

HOST: By all that's holy, I must rush!
 Midnight's past! Today's the day!

STASZEK: They dropped this as they sped away –

HOST: What?

STASZEK: A horse-shoe!

HOST: Solid gold!

STASZEK: I saw it shining in the slush!

HOST: That says more than words untold:
 proof positive which makes it clear
 our fiery guest was really here,
 with his grey charger from the steppes –
 lyre on saddle, tinkling chords –
 eagles, watchwords, scythes and swords!

SCENE 28

HOST, WIFE, STASZEK.

HOST: Hannah, see!

WIFE: That means good luck!

HOST: Luck, good fortune – what a find!

WIFE: Where?

HOST: Near the entrance to the hall!
Pure stroke of luck!

WIFE: It's solid gold!
What craftsmanship! A joy to hold!
Who lost it? We must hide it, love!

HOST: No! Call the guests! It's from above!
This horse-shoe must be shown to all!

SCENE 29

HOST, WIFE.

WIFE: Nonsense! We're the lucky ones:
the horseshoe's got to stay with us.
Keep it secret; make no fuss!
Other folks don't need to see it!
If *we're* in luck for once, so be it!

HOST: Gold!

WIFE: True...

HOST: Stow it in the chest!
You're right, we'd better guard it well;
good fortune's all too rare at best!
Whether the gift's from Heaven or Hell,
it augurs well for what's ahead!

WIFE: What *is* all this? I'm full of dread...

HOST: You cannot grasp how we'll be blest:
misery over, build anew!

WIFE: Meaning what? Build what anew?
 What is it I haven't guessed?

HOST: Eagles, watchwords, scythe and blade:
 gentry, peasants, peasants, gentry –
 all bewitched – it's elementary –
 all a vulgar masquerade:
 peasants, gentry, gentry, peasants,
 sword and motto, shield and scythe –
 enough to make the conscience writhe!
 Nothing but a mean disguise –
 a painted mask to cheat the eyes:
 all enchanted – peasants, gentry!

WIFE: Are you feverish – or what?

HOST: I *have* been feeling rather hot –
 the way volcanos roast within
 and organs make a mighty din.
 Confound those characters in crowns,
 haughty lords with family crests,
 villas, keeps and palaces,
 herds of horses on the downs,
 riders all in fancy-dress!
 Noble be – and life's a spree –
 so enjoy it thoroughly!
 Beware, though, you who wear the crowns:
 we're all teetering on the brink.
 Crested gentryfolk in mink –
 peasants, too, have ceased to care
 who is suffering what and where!
 Ox in field and pig in cloister –
 all make merry, drink and roister!

WIFE: Go and sleep it off! You're tight!

HOST: The whole world – everybody's tight!
 Drunk – or spellbound – day and night!
 Let me alone! I've got to go!
 I've sworn an oath – I told you so!

WIFE: Saints preserve us!

SCENE 30

HOST, WIFE, GUESTS.

GUESTS: What's the matter?
 What has happened?

WIFE: Mad's a hatter!

HOST: You – whoever you may be –
 town-life bores you, so you flee
 to taste a breath of country air.
 You don't rate highly – here or there.
 There's not much left of us, I swear:
 dolls, cribs, icons, vulgar masks –
 gaudy kitsch and leather flasks.
 Gone are the stalwart knights of old –
 great trenchermen, in battle bold!
 Seek in vain those sturdy souls
 who once, half-crazy, played great roles –
 as apt to save, as slash and slay!
 You'll not see their like today.
 To hell with your moods, your airs and graces!
 I spit my pity in your faces!

He spits.

End of Act Two.

ACT THREE

SCENE 1

HOST. Walking about alone, slamming doors, one after another, as they are opened by somebody outside. Finally weary, he settles down in an arm-chair, drowsing. The room is dark.

SCENE 2

HOST, POET, NOS, GROOM, WIFE, BRIDE.

POET: Drunk? (*Referring to NOS.*)

HOST:　　　　　As usual. Drunk as a lord!
　　　　One needs a good, strong Polish head
　　　　to cope with blade as well as glass:
　　　　only a fool sleeps out of bed!

NOS: To cope with glass and loving lass –
　　　　although that's not... Why, no! I see
　　　　the problem from a different angle.
　　　　Something so stirs the heart of me,
　　　　perhaps I ought to mention it:
　　　　vodka and wine may help a bit,
　　　　what really counts, though, is – the sword!

HOST: The sword... what really counts... the sword!

POET: It's very strange... to be deplored.
　　　　Put him to bed –

GROOM: (*Trying to hold NOS.*) – keeps breaking free!

NOS: I'm in a wood where every tree
　　　　scampers off with one accord...

GROOM: Are you bored?

NOS:　　　　　　　　By everything!
　　　　Life for me holds no delight;
　　　　around my heart, a frigid ring.
　　　　My guardian angel's taken flight;
　　　　I feel I'm in a forest where
　　　　every tree just flies away:

dance, dance, dance! Away dull care!

BRIDE: He's half seas over –

POET: Strange to say –

HOST: Everything is always strange,
 everything's of interest.

GROOM: The tone of voice – heart's melody,
 that tone in which the soul cries out –

POET: What is it you want? Don't shout –

NOS: A drop of wine, my throat is dry –

POET: Have some –

NOS: (*To POET.*) I know – *evviva l'arte* :
 life means nothing – one long party –
 cult of Bacchus and Astarte.
 Fate's decrees brook no reverse,
 hence an ever-empty purse!
 Dreams of glory lead nowhere!
 Man must live, though life's a curse...
 Napoleon, at least, had flair!

HOST: (*From his chair.*) Must say, it didn't take you long...
 the wedding's still not two days old
 and you're already on your knees!

NOS: I meant to vanish in the throng,
 sink to their level, so to speak –
 plunge myself from tip to toe
 deep in the robust, healthy flow –
 suppress my personality
 and settle for banality.
 No sooner, though, did nature urge
 my soul to frolic than, despite
 my firm intention to submerge,
 I couldn't help but catch the light!
 I've feelings... Dammit! It's my heart!

POET: Heart disease, eh? That's no joke;
 ought you to drink?

GROOM: One fatal bout –
near lunacy, if you ask me.

HOST: (*Mumbling.*) All the same... sheer misery
to live in ever-lasting drought!

NOS: I drink and drink, because I must;
yet while I do, I feel oppressed
by the heart-ache in my chest.
An awful lot of things I've guessed:
Thus, in plain Polish, I attest –
breezes play, forests sway –
Hip-hip-hooray!
Were Chopin still alive, I think,
he would drink.
Breezes play, forests sway,
Hip-hip-hooray!

POET: Stretch yourself upon the sofa –
sleep it off, then go and dance!

NOS: I danced with a Moravian Sister –
nobody'd given her a whirl;
I felt so sorry for the girl!
She, country lass, I – city wit...
while I sleep, she'll have to bide.

HOST: (*Vacantly.*) Sleep... sleep... let her wait for you;
long the road and far to ride...
the great man gallops tirelessly...

POET: (*To his brother, the HOST.*) You dreaming?

HOST: ... While I slumber here!

WIFE: (*To HOST.*) Go to bed; it's all made up –

HOST: Sooner sit here in my pew!
(*Continues, to NOS.*)
So then, my friend, goodnight! Adieu!
True friends, indeed, are all too few.

NOS: (*Settles down on the sofa; to the GROOM.*)
I was kissing the Moravian,
with a bottle in my grip –

> when the bottle tilted to'ards me
> and the wine began to drip.
> Waste of wine – and all because
> I had the bottle in my grip.
> I struggled to extract the cork,
> but only pushed it further in.
> To hell with it, I thought, I'll work
> it free, with luck, behind her hair –
> (she'd long Moravian locks, this lass) –
> then she could go and get a glass.
> Quite how it happened, I don't know –
> I drank the bottle at one go –
> and drained a lot of hair besides!
> Which so aroused me as I strove,
> that, all at once, I fell in love.
> But when I tried a second kiss,
> a second snag destroyed my bliss:
> I collapsed – and scored a miss.

GROOM: Another time, remember this:
only drink when kissing's done!

POET: First make hay – then live, old son!

WIFE: Be off with you! The time has come!

NOS: (*Singing.*) Tum-ty rum-tum, tum, tum, tum!

BRIDE: Leave them! Do please go – it's late.

POET: Their souls are in a curious state!

GROOM: We only know the half of it
about ourselves; the rest? Who knows –

POET: Where, in his dreams, the sleeper goes?
It's dreadful there, here's bad enough.
I wonder almost every morn,
how much longer this can last...

NOS: I ponder daily on that theme;
once I've slept, I'll deal with it...
I'm awfully tired; my bedtimes's past –
just the topic for a dream!

GROOM: Bathed in sweat, you'll greet the dawn.

POET: He'll need a change of clothes – and fast.

NOS: Eternity – you comprehend?
 Infinity – without an end?
 One more glass, miss, for a friend!
 If we pass out, there will be others.

HOST: Are you or aren't you going, brothers!?
 No squabbling here! Just let me be:
 peace I want... not company!

NOS: If we pass out, there will be others.
 Get you gone! No subterfuge!
 Après nous, le déluge !

*NOS passes out on the sofa, HOST in armchair; the others
leave them sleeping.*

SCENE 3

HEADMAN, MUSICIAN.

In the doorway leading to the wedding-room.

HEADMAN: You miserable shcraper!
 Pay you dance by dance? That's shteep!

MUSICIAN: No haggling master!
 Best go sleep –
 or find some other band to play!

HEADMAN: Confound you, there'sh another day!
 You dare tell me go to bed!
 You've already had your pay!
 I'll teach you to be insholent –
 do you, or don't you, mean to play?

MUSICIAN: No haggling, master!
 Best go sleep –
 or find another band, I say!

HEADMAN: You rogue! You promisht me you'd play!

MUSICIAN: Twenty groschen in advance!

that's nothing for a three-day dance!
You find another band, I say!

HEADMAN: You rogue! You promisht me you'd play!

SCENE 4

HEADMAN, CZEPCOWA (His wife).

CZEPCOWA: Let it rest!
Don't let the fiddlers worry you;
You'll find others glad to play.

HEADMAN: I'll thrash the shcoundrels black and blue!

CZEPCOWA: Best go home, you've drunk a lot!

HEADMAN: Don't nag, woman! Me – half-shot?
Clear off home? That I will not!
Fiddlersh, I've a hefty fisht –
As you'll find out, if you resisht...

CZEPCOWA: Oh, why – oh, why, must you insist?

HEADMAN: I'll teach the shwine a thing or two!

CZEPCOWA: Do let it be!

HEADMAN: Damned insholensh!
Not till I make him shee shome shensh!

SCENE 5

CZEPCOWA, WIFE.

CZEPCOWA: Been asleep?

WIFE: My husband has –

CZEPCOWA: You've had your work cut out, I bet!

WIFE: I hope it's pleased the younger set...

CZEPCOWA: That's just it: life's bright as paint
When you're young – no cause to fret.
Later, it's just one long complaint!
Such a pity, goodness knows!

WIFE: Yes, but that's the way it goes...

CZEPCOWA: The wedding's gone extremely well.
Take those townsfolk, for example:
they're astonished, you can tell –
the sleepless night's begun to show.
But they're entranced, don't want to go.
For them, a great success – that's clear!
You've had so many gentry here!

WIFE: Such fun and games, mid so much woe!

SCENE 6

RACHEL, POET.

RACHEL: For you, a lovely evening this must be:
I'm yours devotedly.
But time, you know, is slipping by,
while neither you nor I come any closer,
because I'm still so shy.

POET: You'd be forever standing by,
waiting for that gale...

RACHEL: This urge; the voices ever softer,
farther off – this music near,
those spectres which I saw appear
in the orchard – why?
Must all this pass away –
must we part from one another –
each forget the other?
That is, when you've forgotten me,
should Rachel then reminded be,
she'll maybe dream
and possibly be sad.

POET: I think that she may be well pleased
with thoughts so resolutely seized
by sadness. Sadness and Beauty overlap.

RACHEL: What if the strings should somehow snap –
the music grief alone recall – ?

POET: Why then, let her put on her shawl,
　　　like Polyhymnia in the garden wait,
　　　thinking which style would be appropriate –
　　　how best to dress for going to a ball,
　　　or possibly a concert-hall
　　　where – who knows – we might meet.

RACHEL: And what of that grief-stricken thrall,
　　　the cloud of sadness on my brow?

POET: What else but literature, my sweet?
　　　Art ready-made!
　　　In one form or another, in it goes –
　　　as sonnet, lyric, or short-story –
　　　if it's prose...

RACHEL: 　　　　　　The music of my heart –
　　　the love – or nearly – which I feel
　　　for you – most dearly – ?

POET: Would find its outlet most sincere, most real –
　　　in verses – clearly.

SCENE 7

HANECZKA, GROOM.

HANECZKA: Brother, thanks for everything:
　　　I very much enjoyed the dance!

GROOM: Did you, little flower?

HANECZKA: As I started to go round –
　　　in the circle, in a ring,
　　　I did so want to have the chance
　　　to kiss a groomsman –

GROOM: 　　　　　　Did you, child?

HANECZKA: A proper kiss, the way you do –
　　　not like children do it.

GROOM: When we kiss – well, I'm a poet –
　　　it's exhausting really;
　　　and the meaning's somewhat other.

HANECZKA: What I feel, though, must I smother
 when I'm boiling over, brother?
 Cracow boys are simply bliss!

GROOM: Maybe so – but not to kiss!

HANECZKA: A kiss is little to bestow –

GROOM: Groomsmen don't deserve it – NO!

HANECZKA: Brother, that's your final word?

GROOM: You mustn't, little flower! You heard!

SCENE 8

POET, MARYNA.

POET: Lovelier still! And you're alone?

MARYNA: My beauty, solitude enhances...
 I see you're busy pinning wings,
 poeticising place and time,
 manor, guests and wedding-dances.

POET: Imagining all sorts of things –
 from monsters to a paradise
 of figures worthy of romances.

MARYNA: There you stand a happy man,
 rich in talent for the rhyme.
 What of us? No poets we!
 Upon us, though – would you agree? –
 a font of tenderness cascades
 whose sparkle every eye pervades
 as though already we could see –

POET: Something new? It's possible –
 just possible – you all could be
 turned into angels overnight –
 this sleepless, dance-filled, magic night...
 What then – ?

MARYNA: As angels, where to start?

The very thing that crossed my mind!
We'd harness horses to our coach,
climb in, the coachman – for his part –
would crack his whip and all –

POET: Depart?

MARYNA: But who, I wonder, could maintain
this lofty tone without reproach?
Just now, while I was standing near
the band, I chanced to overhear
peasants talking about Poland...
chatting frankly, making sense:
this and that they'd have to beat,
not give in – to live and eat;
they couldn't stand it any longer!
Seemed to me their arguments –
were soundly based, without pretence.

POET: *If* something were to happen...

MARYNA: (*Correcting.*) *When* !?

POET: They're always grumbling, these men,
why should you think –

MARYNA: But that's just why!

POET: So, moved by impulse...

MARYNA: Impulse? I?

POET: They and we – we and they
are vying hard for right of way –

MARYNA: – while *you* ride Pegasus in cloud.
It seems to me – there's something in it.

POET: What you heard out there?

MARYNA: There... here. All Poland's nature – cowed –
has changed.

POET: What proof?

MARYNA: I prophesy aloud.

POET: You think my nature, too, has changed?
 But, in my case, I doubt that's so.
 I'll tell you straight, if you must know,
 the truth about myself: I hide
 from myself – in fog reside.
 Vulgarity, stupidity
 like dogs about me slink –
 cling to my hands,
 cling to my feet,
 dragging me back – a forced retreat
 to mist and darkest night.
 Madness! Everywhere, my glances
 rest like poeticising blight –
 and all within me dances:
 sadness, mist, the vile and trite –
 while my wings are weighted down
 with the force of others' tears.
 Somebody weeps
 and to my soul each teardrop clings.
 My spirit cannot lift its wings
 and trammeled, as it were, I listen:
 somewhere high above our heads –
 on a roof or in the clouds –
 bitter tears the weeper sheds.

MARYNA: What is it? Are you feeling ill?
 why not go out – cool off outside
 in the gale?

POET: More fevered still!
 the orchard there will spirit me away –
 orchard where trees gigantic loom,
 where bushes, trunks and leafy spray
 spawn an air of awesome gloom,
 rusting in darkness, by degrees,
 like tranquil Slavic deities...

MARYNA: Truth will always out, one day...
 What is it causes you such pain?
 Perhaps a thought..?

POET:⠀⠀⠀⠀⠀⠀⠀⠀⠀What gives me pain?
⠀⠀That one says I should harvest grain –
⠀⠀another bids me shun the land;
⠀⠀one urges me to spread my wings –
⠀⠀another seeks to keep them pent;
⠀⠀one veils my eyes with cautious hand –
⠀⠀another shines a light instead;
⠀⠀one of these hands is heaven-sent,
⠀⠀the other cursed by ill-intent;
⠀⠀while Fortune shuns me in all things,
⠀⠀Misfortune hugs me to its breast.

MARYNA: You don't forget a word that's said:
⠀⠀you take it all to heart – with zest!

SCENE 9

HEADMAN (Now sobering up.), KUBA.

HEADMAN: Clear out of here, you cheeky brat!

KUBA: Headman, listen – please don't yell!

HEADMAN: Get out from underneath our feet –
⠀⠀this room's the senior folks' retreat!

KUBA: But I know something I could tell,
⠀⠀if you would not be mad at me –

HEADMAN: What?

KUBA:⠀⠀⠀⠀⠀⠀⠀You'll soon leave here with him!
⠀⠀*(Pointing at HOST.)*

HEADMAN: *(Also pointing.)* With him...

KUBA:⠀⠀⠀⠀⠀⠀⠀⠀Asleep...

HEADMAN:⠀⠀⠀⠀⠀⠀⠀⠀Where?

KUBA:⠀⠀⠀⠀⠀⠀⠀⠀⠀⠀Muscovy!

HEADMAN: What, me with him? Why, he's passed out!

KUBA: Hush! Dreaming... I know what about!
⠀⠀Some lord came calling here last night –

 he'd shoulders like a baker's oven!

HEADMAN: A famous man, without a doubt –
 with shoulders like a baker's oven!

KUBA: Stopped on horseback in the yard.
 After talking privately (*Points at HOST.*)
 with him asleep, the lord comes out,
 grabs Jasiek, mounts and gives a shout:
 "Brothers! Down with Muscovy!"
 We eavesdropped, Jasiek, Stas and me,
 and I can tell you what we heard
 him, there, and this lord agree.

HEADMAN: A lord – ?

KUBA: From the Ukraine, I'd say.
 Frightfully rich, to judge by dress,
 but awfully Polish in his way...

HEADMAN: Old – ?

KUBA: A hundred years, I'd guess.
 He talked of slaughter blood and gore –
 all homesteads must be roused tonight!
 The lord was ready, come what might!
 They took no time to hatch their plan;
 no sooner had they finished than
 we three took to our heels and ran –
 back to the stable, as before –
 like we'd been seeing to his grey.

HEADMAN: The horse was grey – ?

KUBA: As milk or snow –
 and wore a golden cover-cloth.

HEADMAN: Could be a trap, from what you say;
 what does Satan take me for!?
 Who else saw him?

KUBA: No one did.

HEADMAN: Staszek's an idiot; you're a kid!

KUBA: You don't believe me? There's the shoe;

that horse of his was shod with gold!
He lost a hoof, picked up by me.

HEADMAN: Where is it?

KUBA: Mother took it, she
hid it away inside a chest.

HEADMAN: Hid the horseshoe in a chest – ?
and never showed it to a soul?
I s'pose she thought it would be best –
a wise decision, on the whole.
Lucky for me, too! Now I know
it's with him we're s'posed to go.
Kuba, listen, come with me;
black as pitch, out there... can't see.
We're assembling. Fetch a glim –
(Gestures towards sleeping HOST.)
Wait, I want a word with him!

SCENE 10

HEADMAN, GRANDAD.

HEADMAN: *(Moves away from the door as someone enters.)*
Yes?

GRANDAD: Headman, something I must say –

HEADMAN: Can't you see you're in the way?

GRANDAD: Do take care, for pity's sake!
Among the peasants, word's gone round.
There's something brewing by the sound.
Folks bringing out their armoury.

HEADMAN: Granddad, what must be, will be!

GRANDAD: Jasiek's scouring valleys, plains –
Tapping on folk's window-panes.

HEADMAN: And where've I been? Ashleep, you think?

GRANDAD: Headman, you've had a drop to drink!

SCENE 11

HEADMAN, WIFE.

WIFE: He's asleep.

HEADMAN: Asleep you say.

WIFE: He raged and stormed – quite out of hand!
 Imagining he saw the past.

HEADMAN: He said some things of interest –

WIFE: That nobody could understand –

HEADMAN: Things about to happen, eh?

WIFE: Topsy-turvy, vague at best:
 gather somewhere, somewhere go –
 possibly to fight some foe.

HEADMAN: No bad thing, that – in its way...

WIFE: Perhaps you, too, would like to flee
 on horseback?

HEADMAN: Where to? Far away?

WIFE: Don't ask *me* !

HEADMAN: That's all he told you?

WIFE: Nothing more...

HEADMAN: Each to his taste. But me? I'm for!

SCENE 12

RADCZYNI, JOURNALIST.

RADCZYNI: With such absorbing work to do,
 it's curious that a man like you
 is lured by a wedding –

JOURNALIST: Always glad
 of respite from stupidity.

RADCZYNI: But yours is serious work – or not?

It strikes me as a little sad
that you refer dismissively
to something serious.

JOURNALIST: Nothing's serious.
All things are provisional:
statement, opinion or conviction.

RADCZYNI: Truth, however –

JOURNALIST: Truth's a fiction!

RADCZYNI: That depends upon the man
but if you yourself, sir, can
desert your post –

JOURNALIST: A toll I levy...
Mine's not an outpost after all;
and filling sieves, a pointless chore!

RADCZYNI: So you amuse yourself a lot?

JOURNALIST: When life's a bore...
I'm forced to grind so in my mill,
I make quite sure I have my fill
of parties, games of whist and meals
with near and distant friends, at will.
But as the years and days go by,
some lose touch and others die.
I sit and brood, or go to bed –
or, from sheer boredom – dress instead.
Just now, a wedding fills the bill;
though, frankly, there are those I dread,
this wedding, by and large, appeals.

SCENE 13

RADCZYNI, BRIDE.

RADCZYNI: My lovely lady, young and active,
how will you get along together?

BRIDE: All right, I s'pose. I wouldn't bet:
we've not agreed on that as yet.

RADCZYNI: Your beauty, as I'm well aware,
 will sometimes lead to stormy weather:
 you're young and you're attractive...
 What topics will you find to air
 as longer evenings stretch ahead?
 You'll be tongue-tied, night and day:
 he's clever; you've not been to school!

BRIDE: Madam, he'd need to be a fool,
 to talk to me, with nowt to say –
 silence is golden – that's the rule!

SCENE 14

BRIDE, MARYSIA.

MARYSIA: I'm happy, sister, but I fear
 that you may one day have regrets.

BRIDE: What regrets?

MARYSIA: Remember how you used to chase
 Pepper and Salt, our speckled hens?
 You were still little, keeping pace
 with Hanna and myself, all three
 of us at home together.
 You'll miss the stable and the farm
 the simple life with all its charm –
 even the way you had to work,
 the endless toil of peasant life.
 Now you've become a gentry-wife,
 I'm happy for you but I fear
 that one day, you may have regrets...

BRIDE: What regrets – ?

MARYSIA: Only that perhaps you'll yearn
 for daddy and the family,
 the garden, every fence and tree;
 that, much as you may love your swain,
 in tears, you may fly home again,
 for here, your soul will always be,

and heart made welcome on return,
while there, you'll likely feel alone –
to fits of gloom be prone –
and then you may regret...

BRIDE: Little damage, brief regret!

MARYSIA: For you, all's wonderful as yet!
Blush and burn, but don't forget
That – here, your soul will always be –
here, your loving family.
There, you'll likely feel alone –
To fits of gloom be prone –
And then you may regret...

SCENE 15

MARYSIA, FATHER.

MARYSIA: Are you enjoying it, Papa?

FATHER: Let them amuse themselves, have fun!
It's only for a day or two –
then they'll go their own sweet way –
no longer in my care.
Let them paddle their own canoe
as they like – not my affair.

MARYSIA: But Papa, you'll see we share
the money from each sister's plot?

FATHER: I'll do my best; rich – I am not!
You were wed as you desired –
if not the first time, then the second!
Each time, the dowry you required,
would be the same, I reckoned.

MARYSIA: You'd have been better pleased, would you,
if I had wed the gentleman
who wanted me so long ago?

FATHER: The one who died? But he withdrew.
The Headman had arranged the match –
you were the one he chose, I know.

MARYSIA: I truly loved him, on my oath;
 today, as Jaga pledged her troth
 I remembered my dead friend –
 how Hannah's wedding taught us both
 to know each other. Sorry end!
 Gloom overcame me, I confess;
 I really don't know why –
 preferred my own, I won't deny...
 Perhaps just loneliness.

FATHER: Where *is* your husband?

MARYSIA: Sound asleep,
 tired out. He told me to come here,
 so I came – the Lord knows why!
 There's nothing here for me;
 they're dancing now, as years ago,
 when go-betweens went to and fro
 my hand to seek for prince and peasant.
 I was in love then; life was pleasant.

FATHER: Go join them –

MARYSIA: Sooner watch from here.
 The girls look paler every dance,
 so tired, yet blissful, they can't stop –
 they'll pirouette until they drop.

FATHER: Why don't you dance?

MARYSIA: I've had my fill...

FATHER: In tears?

MARYSIA: The mist before my eyes
 makes everything look paler still.

SCENE 16

POET, BRIDE.

POET: Young lady – fresh from sleep, no doubt?

BRIDE: Not slept a wink;

> but dreamt, I think,
> as I lay resting, quite worn out.

POET: Weak from love, the bliss of marriage...

BRIDE: In my dream it came about:
> I met the Devil in a carriage –
> huge and golden! Dreams *are* silly!
> One talks nonsense, willy-nilly.

POET: You met the devil on the scout –
> suddenly, in a coach of gold?!

BRIDE: Yes – in a dream – events untold
> seem everyday – no matter what.
> Don't scoff at me for talking rot;
> if you'd seen such a thing, I swear,
> you'd brag about it everywhere
> as a marvel – which it's not.

POET: For that, some folk would pay a lot;
> with one such tale one could afford
> to buy oneself a coach, complete
> with Devil splendidly attired –
> and give the passers-by a treat.

BRIDE: The dancing made me feel so tired...
> I dreamt I took my seat inside
> the coach and, eyelids drooping, tried –
> as there I sat and dreamt unknowing –
> to see where they were taking me:
> forests, a town with walls I spied:
> "Where the devil are we going?"
> I inquired. The Fiend replied:
> "Poland!" "But we're there!" I cried, –
> "Don't you know?"

POET: The whole world over,
> Poland, dear lady, you may seek –
> but Poland you will not discover!

BRIDE: No point in searching, so to speak?

POET: There *is* one little caged retreat:

if Jaga, you would kindly place
hand below breast –

BRIDE: That's just a pleat
in my bodice – sewn too tight.

POET: – – – You feel the thump?

BRIDE: What of it? Isn't it a pump...
My heart – !?

POET: Your heart is Poland. Right?

SCENE 17

POET, GROOM.

GROOM: Very cold it gets round dawn.
This night without a wink of sleep,
I shall not easily forget.

POET: A wedding night of such a length
must always be a test of strength.

GROOM: Partly that, but more besides:
like pliers wrenching my insides,
terror and immense foreboding,
fear of humdrum life eroding
this – our magic, spellbound world;
that all we saw, as though alive,
could vanish, by the tempest whirled
and we'd have proffered hands in vain
to spectres that were nothing more.
My fantasies grew dim before,
at last, they settled down to snore
in the ghosts' enchanted wood.

POET: For my part, I'm still feeling good –
borne aloft by last night's gale.
I'd say my striving soul is stood
upon a rearing pinnacle,
and there, henceforth, shall safely stand,
sure of the strength I now command!

GROOM: But none of that is worth a light –

POET: Agreed, if Satan flies by night...
 Night's not yet fallen: that's the thing!

GROOM: Shoot at eagles with your sling!
 But I prefer a peaceful glade,
 an orchard, scent of flowers, shade,
 apples blooming all around –
 stalwart thistles, fluffy-crowned –
 meadow grasses, green with life –
 and, walking at my side – my wife!
 A private corner, by God's grace –
 some tiny spot, the sort of place
 Stanisławski loved to trace,
 where apple-trees and thistles teem
 in the golden sunset's gleam...
 There to be in peace and quiet:
 the nearest thing to noise and riot –
 droning bees and glossy flies!

SCENE 18

As before with HEADMAN.

HEADMAN: (*In sheep-skin coat, holding large scythe.*)
 Ah, gentlemen, you're here!

GROOM: A scythe?
 How pretty!

HEADMAN: Yes – but not for play, sir!

GROOM: You've honed it sharper than a razor...
 Fit to slaughter. What's it for?

HEADMAN: I've fixed it up for when we go;
 but I can see, sirs, you don't know
 what it is that's now afoot.

POET: You've business, Headman, with my brother?
 What's the cause – ?

HEADMAN: Cause is right!

GROOM: Interesting –

POET: Curious sight!

GROOM: I mean, I'd like to know the reason
you come rushing in here, out of season.

HEADMAN: You must be blind, sir – don't you know?
Didn't he summon you?

POET: Come, come!
My brother's snoozing... can't be woken.
Is it grave?

HEADMAN: A scything matter!

POET: If he wants it for a picture,
stand it in the corner, will you?
When he wakes –

HEADMAN: I've got you, brother!
Picture-painting time is past –
canvas, portraits – stuff for gents!

GROOM: Headman, why this insolence?

HEADMAN: Your stuck-up manner gives offence;
you screw your face up when I speak –
we can't make sense of one another.
Waste of time consulting gentry!

POET: Fact is, we're town and you are country!

SCENE 19

The foregoing and HOST.

HEADMAN: (*Goes over to sleeping HOST and tugs his arm.*)
Hi there, sir! You're still asleep!
Wake up, sir! I'm surprised at you!
Get up! We've got a job to do!

HOST: (*Waking up, speaks from armchair and chairs on which
he's lying.*) What the – ? You there, what's the fuss?
Hannah, dear! Where are you?

HEADMAN: (*Half-closing door to main room.*)
 Shush!
 The lady doesn't need to hear
 what I want to say to you.

HOST: Why burst in – yelling in my ear!?
 What's up? That scythe, there – what's it doing?

HEADMAN: Out in the country, trouble brewing:
 folk are gathering out of doors –
 already marching – and he snores!!
 You've overslept!

HOST: Why me? What ails you all? What's wrong?

HEADMAN: Duty calls me; can't stay long!
 I was roused and now I'm ready:
 came here thinking I'd receive
 further orders, by your leave –
 to find you're still not half-awake!

HOST: Why the scythe, for heaven's sake?

HEADMAN: I've not been dreaming! What I heard
 was, someone told you: "Spread the word!"
 something of extreme importance –
 gave you papers; is it true?

HOST: Me? Papers, orders? Who? What tosh!

HEADMAN: Get up, sir, quickly! Have a wash!
 Don't keep me waiting here in vain –
 wasting time with none to spare!
 You're supposed to lead the peasants.
 They've all rallied and they're here –
 armed and waiting to appear!
 They've been hiding near the wells.
 At daybreak, as the number swells,
 They'll assemble in the square.

HOST: My mind's a blank, I must confess...

HEADMAN: In Cracow, all's in readiness!

HOST: What nonsense have you been concocting,

 friends and peasants, all night long?
 Me – with you?

HEADMAN: You with us!

HOST: All with scythes? That's dangerous!

HEADMAN: Razor-sharp, just look at mine!

HOST: There's been a sign?

POET: Some sort of sign?

HEADMAN: Rally, while you've still the chance!
 You'll be glad! Don't look askance,
 fluttering like moths round flame,
 or mocking me! This is no game!
 Snatch up arms of every kind
 and into the courtyard! You will find
 men already waiting there,
 desperate to do or dare!
 Peasants – simple folk and fine –

POET: A sign of sorts?

HOST: Some sort of sign!

HEADMAN: Gentry you are and best beware:
 come with us at once or we'll
 come for you – with scythemen's steel!

HOST: You, as –

POET: Do you know our kind?
 What do you know about us? Nothing!

HEADMAN: This I know, sir – you are blind:
 you don't know *us*, who live round here!

GROOM: I see, you've bloodshed much in mind;
 but bloodshed's out of date, I fear!

HEADMAN: Young man, you're newly married, so –
 excited by this pomp and show,
 no wonder you're not thinking clear!

HOST: Your words have shamed me, I admit –

though I rejoice to see your faces!

HEADMAN: Blazing torches you have lit
from the radiance in our faces!
Do you remember – in your youth –
you used to whisper prayers at night?
Our Blessed Lady spoke the truth
about the mighty power of Right
within us, which, though long in thrall,
we would finally recall...
Blazing torches you have lit
from the radiance in our faces!

GROOM: So, presently – by scythe empowered – ?

HEADMAN: Why should I wait? Am I a coward?

HOST: Easy, friend! A quiet word –

HEADMAN: Let him take heed of what he's heard!

GROOM: I don't like your bullying tone –

HEADMAN: You're all piss and wind alone!
Poetry, verses, books and that –
ribbons and feathers in your hat,
peasant greatcoat, colour rust –
but when you're asked to make a stand,
can't see your bloody heels for dust!

POET: But nothing's happening tonight.

HEADMAN: Then why go on about it so?
I'm told by people in the know
a general call to arms was planned.
The great event?

HOST: Which? What!?

HEADMAN: First light!!

POET: First light! See there – a wondrous sight –
a spectral shape of cloud, by breeze
at will propelled, in crazy flight
across the cornfields –

GROOM: (*Towards the window.*)
 Sparks one sees
 on leaves by opal dew-drops spread,
 sowing their diamonds on the ground
 from trees by glittering creepers bound:
 a wonder!

HEADMAN: All you see are fleas –
 fleas, dew, spectres, moths and snow!
 Us peasants, you don't want to know:
 nor that, in our souls, it's light
 and presently the cock will crow;
 that there, in town, they wait for us –
 that here, we number twenty plus –
 armed with sickle, scythe and flail:
 we're no dream, nor fairy-tale!

POET: Funny he should talk of this;
 only today, quite vividly,
 I thought of it as a play, or dream...

GROOM: What a topic!

POET: Peasant blood –
 peasant fury in full flood!

HOST: You say they wait – for us? For you?
 Hold hard! Yes... someone, somebody
 did mention this affair to me...
 Who was it, though..?

HEADMAN: It was a man
 who travelled here from miles away;
 from the Ukraine, or so I heard.
 He it was who brought you word,
 the call to arms, with plans well-laid.
 There's men outside your door who say
 that, on the point of midnight, they
 could swear a lyre was played.

POET: (*To his brother.*) A tinkling lyre at midnight – yes!
 While you lay snoring, powerless –

I heard it!

GROOM: True, and so did I –
 from the courtyard, from the orchard!

POET: Near the apple trees it played,
 but I thought my ears betrayed;
 perhaps a guest in bells arrayed?

HOST: Someone a bit like that was here –
 but different – I can't quite recall –
 it's coming slowly –

HEADMAN: Gentlemen –
 ghosts are your main concern, I fear!
 Let somebody go cast an eye
 outside, beyond the fields, and spy
 anything on the road to Cracow.

POET: (*Going outside.*) Should spot movement – or the lack of –
 I'll observe; it's very near.

SCENE 20

GROOM, HEADMAN, HOST.

GROOM: Why all this rage for rights and wrongs?
 Your face is flushed; are you all right?

HEADMAN: The sky is flushed with reddish light;
 the breeze is wafting battle-songs!

GROOM: You're feverish, headman, I believe:
 hallucinations... ringing sound –

HEADMAN: Young man, my ears do not deceive:
 peasants tramp and horses pound –
 go and look!

GROOM: (*Runs outside.*) What is it now?

SCENE 21

HOST, HEADMAN.

HOST: You're sozzled, chum – and so am I;
 you look good, though – scythe in hand!

HEADMAN: Bloody hell, why this delay?
 The men are eager for the fray!
 Get moving, lads! You, Kasper – act
 as sentry; keep the entrance clear!

He has been shouting through half-open door. Enter two labourers with scythes fixed. One of them is KASPER *in bridesman's dress. They stand guard – one at a door in the background, the other by the door to the wedding-room.*

SCENE 22

HOST, HEADMAN, FARM LABOURERS.

HOST: (*To* KASPER.) Shut it! Keep the women out!
 Now, what's all this hullabaloo?

HEADMAN: Somebody called on you – but who?
 Listen! If it's God you fear,
 you and us best make a pact!

HOST: Wait a moment, I recall –
 someone came here, as you said –
 such a turmoil in my head!
 Can't think who it was at all...
 New impressions cloak the old;
 fresh ideas swarm overall.

HEADMAN: You'll only let your heart grow cold
 with all this thinking, brooding on it –
 my advice is: shit upon it!

SCENE 23

As before, plus GROOM.

GROOM: (*In the doorway.*) A flock of snow-white pigeons rose

and Jaga, startled, screamed aloud.
The air was swirling with the crowd –
they whistled past my very nose!
Come here, love!

KASPER: (*At door to wedding-room.*)
 No. She ain't allowed!
Serious problems being solved:
you go in, sir – you're involved,
they just don't want no women there.

SCENE 24

As before, plus BRIDE.

BRIDE: (*She pulls the door sharply and pushes KASPER out of
the way as she enters.*)
Mind out, you nitwit! Don't you dare!
You want to keep me out, you oaf?
There you stand, stick in hand –
Who do you think you're trying to scare?
You idiot! Go boil your loaf!

GROOM: What's all this about?

KASPER: My lady!
You should be in bed with him!

BRIDE: You've all stayed up too late already.
What a fug! Your wits are dim!

SCENE 25

As before, plus POET.

POET: (*Running in.*) A hurricane of pitch-black crows
from a nearby field arose
and, cawing mightily, sped away.
Such were the deep and resonant notes
that issued from their pitch-black throats,
they'd polished off a field of oats,
I'd say!

HOST: No, brother – that's not it.

POET: There are wonders in the clouds –

GROOM: (*Towards the window.*)
 Scarlet roses, could have sworn:
 you've but to blink your eyes to spawn
 weird vistas in the early dawn...

POET: The clouds have moved to form a throne,
 beside which what appear to be
 winged figures –

HEADMAN: Is that all you see?

SCENE 26

As before, plus WIFE.

WIFE: (*Entering excitedly.*) Listen, lads, come out and look:
 from here to Cracow, fields entire
 aswarm with reapers wielding scythes!
 Looks like an army under fire!

HOST: What! Already!?

POET: Quite a show!
 This I must see! You're all aglow!

 Runs out, dragging WIFE after him.

SCENE 27

As before, less WIFE and POET.

GROOM: Why are you here?

BRIDE: (*Pulling him with her.*)
 Come out with me!
 These are signs – the things they've seen!

GROOM: What on earth can all this mean?
 All very odd! A strange affair!

 Both run out.

SCENE 28

As before, less BRIDE and GROOM, POET.

POET: (*Quickly returning.*)
>I heard a tumult in the air:
>the sound of voices, speech and song.
>but chilly gusts of wind ere long
>blew it in a fresh direction.
>What was visible, they said –
>indeed, awaiting our inspection –
>all of a sudden – good as dead!
>Silence; singing at an end –
>even the bushes ceased to bend...

SCENE 29

As before, plus GROOM.

GROOM: (*Rushing in.*)
>Dawn's produced a gory blend:
>over Cracow, all the sky's with
>crimson trails of blood awash –
>making Zygmunt's tower appear
>to sport a two-pronged, red moustache!

SCENE 30

As before, plus BRIDE.

BRIDE: (*Rushing in.*)
>A giant bird, before my eyes,
>perched upon the balustrade –
>a raven of astounding size –
>which then, in an attempt to rise,
>fell heavily, with wings outweighed,
>among the birches. Twigs it shattered,
>showers of silver dew-drops scattered –
>then it walked away.

SCENE 31

As before, plus WIFE.

WIFE: (*Interrupting.*)
 The Lord forbid!
 What are you doing? What's all this?
 What are you up to – scythes and all?
 (*To HEADMAN.*)
 Out with you, Headman! Into the hall!
 You've none of you slept a wink all night –

KASPER: They're pouring in! Still more in sight!

SCENE 32

As before, plus many PEASANTS, with scythes and other weapons,
 dressed for the road.

WIFE: God protect us! Fresh alarms!
 Why are they carrying scythes?

HEADMAN: For arms!
 Don't nag us, mother – not today!
 We've got to go –

HOST: We must away!
 It's dawning on me... with the light!
 Everyone's seen some wondrous sign.
 Dreams, legends, thoughts of cockle-blight!
 Clear the weeds! Yes – pluck them out!
 I wish I could be free from doubt:
 who was it.. ordered – what?

POET: (*To HOST.*) What's wrong?
 You seem to be in violent pain.

GROOM: (*To BRIDE.*)
 The mists are clearing from the plain;
 this morning will be lovely, Jaga!
 Last night, we'd storms; the heavens burst –
 today the clouds have all dispersed...
 I love you, sweetheart. Now, you're mine!

POET: (*To HOST.*)
 Last night a ghost appeared to me,
 black armour-clad, antique design –
 dropped in – unceremoniously –
 and shouted words; words so intense,
 it strained my ears to catch the sense!

HOST: (*To POET but heard by all.*)
 My head's like lead, my brain feels dense...
 This morning breeze could be the cause.
 Brother, could they perhaps have heard
 far-off singing and applause,
 air-borne, from some distant revels?

POET: Riding the winds, perhaps twas devils
 chanting, with their blood-red paws
 daubing the clouds –

GROOM: The sky appears...

HOST: (*To POET.*)
 You just said, you strained your ears..?
 Where was it, that I heard that phrase –
 from someone, somewhere: "strain your ears"?

SCENE 33

As before, plus HANECZKA, ZOSIA.

HANECZKA: (*To GROOM.*)
 There's commotion in the heavens:
 wonders worked and wars being fought –
 horses galloping through the clouds...

ZOSIA: The morning air is rich with scent!

HANECZKA: Horses galloping, hell-bent;
 also giant knights with spears,
 waiting in two equal ranks;
 across a cornfield they've agreed
 to undertake one last stampede.

GROOM: It's bordering on lunacy
 to think that any man alive

> from wondrous visions could derive
> meaningful conclusions.

HANECZKA: (*To HEADMAN.*)
> Look at that enormous blade,
> why, mister, it's a prodigy:
> might have been expressly made
> to cut the heavens into strips –
> like you would a linen sheet.

HEADMAN: Slice the heavens? God forfend!
> That remark was indiscreet:
> what we need to serve our end
> is fighting-talk not blasphemy!
> You're very self-possessed, my sweet,
> but scythes are not your line of country!

HANECZKA: Easy, mister! What effrontery!
> Give it me, at once, d'ye hear?

HEADMAN: Not for the likes of you, m'dear!
> Our cause is different –

HOST: (*To POET but heard by all.*)
> Cause? A quest!
> A Spirit! Now I recall – a mission!
> Last night it was, I had a guest...
> sort of day-dream, premonition...
> rally supporters... his request!

POET: I saw a Knight in armour clad;
> as you say – a spirit –

HOST: Yes!
> Brothers, a Spirit came our way:
> I see him still as plain as day.
> Now I remember, I remember!
> An old man with a grizzled beard,
> grey whiskers all around his face,
> wearing an outsize scarlet coat –
> he was here!

STASZEK: (*He has worked his way to the HOST, through a
crush of peasants – men and women crowding into the*

 room.) We saw him, true!
 We held his horse for him – us two!
 White horse it was!

KUBA: (*Behind STASZEK.*) He had a lyre –

HOST: I'm thinking hard; I'm listening!

POET: Lyre on his saddle –

STASZEK: Pistols slung –

HOST: My brain is itching – like being stung!
 I'm thinking hard –

HEADMAN: (*To the crowd pressing round the HOST.*)
 He's thinking hard!

WIFE: Oh, my God – he must be ill!

HOST: I'm fine; it's gone – that nightmare aura!
 Listen, friends! Hear me – your host!
 A Spirit came here: Vernyhora!

ALL: What?! You say you saw a ghost?!

HOST: Flying by night from hall to manor;
 calm of bearing, but what strength!
 Orders he gave me – watchwords, signs –
 explaining everything at length.
 Nothing could quell such bold designs!
 He hurried off without delay –
 lots of manors still to visit –
 and return by break of day.

ALL: Here? By dawn?

HOST: That's it – first light!

ALL: He ordered what?

HOST: Prepare to fight!

POET: (*To the SCYTHEMEN.*)
 Lord God! That's what you've come for, is it?

HEADMAN: All kinds of folk were here tonight;
 these stable-lads were our first source –
 they told us how they held his horse

while it was waiting in the yard.

STASZEK: Some nag! It bucked and kicked that hard!
 We grabbed the bridle, best we could –
 look! Mine and Kuba's face is scarred –
 what kind of man would ride that stud?

HOST: Vernyhora! Vernyhora!
 I've awoken from my dream:
 to arms! Bring out your arms, he said –

POET: And ride?

HOST: No, no! Wait here instead,
 until cock-crow, listen out –
 strain our ears to catch the sound
 of cavalry from Cracow bound,
 coming here along the road...

WIFE: (*From the neighbouring room.*)
 Hey! The courtyard's overflowed!

BRIDE: (*At the door.*) With *our* folk?

WIFE: (*From neighbouring room.*) From Tonie, too –
 people pouring in pell-mell –
 scythemen – far's the eye can see!

POET: All illusion!

HOST: Destiny!

POET: Something to rouse the soul at last –
 after long years in silence passed.

GROOM: A flash of light, a blast of sound –

POET: A heart that clamours lustily!

HEADMAN: You've heard it, eh? You're coming round!

POET: All this listening out... for what?

HOST: We're to hear the tramp of feet –

POET: Horses' hooves –

HANECZKA: Who's coming here?

HOST: Not here! Out there, along the road –

 the old grey minstrel at the helm!

HANECZKA: Old Vernyhora leading them?!

HOST: With his lyre, he'll bless the realm –
 as he does, our caps we'll doff –
 then, all to horse –

POET: And gallop off!

HOST: I don't know... there's more beside –
 some secret... dawn...

POET: Still dark outside!
 Dawn's a long way off, I'd say –
 the first faint flicker far away;
 but dawn..?

HEADMAN: Three times the cock must crow.

HOST: A sign...

POET: Those phantom shapes on show
 in the clouds, mean..?

HOST: Ghosts, you say!

GROOM: Along with the clouds, they've blown away;
 all's quiet now, there's not a sound!

POET: Listen!

HEADMAN: Listen!

HANECZKA: Listen!

HOST: There's...

GROOM: (*Listening at the window.*)
 A rushing noise! My ears surmise
 something tangled in the pear-trees,
 caught by the branches –

POET: (*Amid general silence.*) Buzzing flies,
 that swarm above dry mallow-stumps
 before the break of day.

WIFE: (*In whisper.*) A crowd of folk have knelt to pray.
 Look! Near the manor – on their knees!

BRIDE: (*Crying out.*) No end of curiosities!

HANECZKA: (*Between the* HOST *and* HEADMAN; *almost in
 tears.*) Is it true, alone he'll ride?
 or someone with him? If so, who?

HOST: He'll have an Archangel at his side,
 so kiss the ground, or woe betide!
 From Cracow coming, they'll be seen;
 the Royal Castle's where the Queen
 of Czêstochowa waits...

POET: Take heart!

HOST: Listen! Listen – for the start!

HANECZKA: I'm listening, God help me!

WIFE: Where?

BRIDE: There, far away, I hear –

GROOM: You swear?

POET: (*In low voice.*) Dry leaves falling from the trees...

GROOM: (*In a whisper.*) There's not the faintest whiff of breeze.

POET: Two crows have taken to the air
 from the orchard –

GROOM: From the garden –

BRIDE: Into the fields!

HOST: Be quiet!

HANECZKA: Hush!

WIFE: (*Amid total silence.*) I hear something...

POET: (*Cupping hand to ear, bends his head towards his brother's
 breast.*) Dawn's first blush!

HOST: Listen!

POET: (*Sounding certain, hand to ear.*) By the living God!
 Strain your ears! There's something odd –
 I can hear –

HOST: Whisht!

GROOM: (*Ear pressed to the window-pane.*)
 Someone racing!

HANECZKA: (*Musing, face in her hands.*)
 Zosia! Zosia! Oh, please God!
 He's coming!

ZOSIA: Galloping!

HOST: Break-neck!

POET: Chasing!

HEADMAN: (*Straining to hear.*)
 At least a hundred horses racing!

WIFE: Tramping –

KASPER: Stamping –

BRIDE: Pounding –

POET: Chasing!

HOST: Hush! It's day-break, day-break! Light!
 By God! He's almost here – in sight!
 It's him – shush! Must be Vernyhora!
 Bow the head! He comes afresh –
 spectre, spirit, ghost made flesh!

POET: With his lyre, the dawn embracing!

GROOM: Tramping –

BRIDE: Stamping –

WIFE: Pounding –

HEADMAN: Chasing!

*All listen intently, leaning towards door and window – in
immensely emotional silence.*

HOST: Listen, dear ones, let us pray
 that everything we've heard is true:
 that Vernyhora's on his way –
 Archangel with him, in the van;
 that, on this wedding night of music,

> while we've all been busy dancing,
> things elsewhere have gone to plan;
> in Cracow, lit by many a fire,
> God's Mother, crowned, in royal attire,
> on Wawel Castle's throne would then
> a rousing manifesto pen –
> inspiring words which, countrywide,
> must rally thousands to our side!
> Hear now my panting heart's amen
> that all of this has come to pass,
> and Vernyhora here may ride –
> with herds of horses, droves of men!

GROOM: Coming ever closer!

POET: Kneel!!

HEADMAN: They've halted – horses, men – the lot!!

HOST: In silence, rooted to the spot!

HANECZKA: (*Exalted.*) Is the Archangel there, or not?

All bowed, half-kneeling, listen with rapt attention; scythes firmly grasped in right hands; some holding swords taken down from the walls, others with shotguns or pistols. Their attention resembles spiritual exaltation; hands cupping their ears. The noise of hooves approaching becomes audible, suddenly nearby, then closer still, before stopping abruptly.

After a few moments, the sound of heavy footsteps in the hall, quick and violent, then in the neighbouring room, finally reaching the door in the background, at which is posted the first GROOMSMAN.

SCENE 34

JASIEK.

JASIEK: Mary, Mary! Jesus, Lord!
 The horse has fallen in the yard!
 (*Looking around him.*)
 What's this? Hanka! Jaga! Hey!
 what's the matter, Jaga – eh?
 (*Peering at their faces.*)

What ails you? Are you spellbound or
dead – and rooted to the floor?
Listen Hanuś, Błazek, mother –
bridegroom, Headman – answer, father!
Sir, what is it? Spellbound or
dead – and rooted to the floor?

Ah, yes! True as I was born,
I was meant to blow the Horn;
I've lost it – don't know where it's gone –
perhaps the buckle came undone;
the sling is all I'm left with now!

*At this moment, from a back room, the shambling figure of
the STRAWMAN enters in the wake of JASIEK.*

SCENE 35

STRAWMAN, JASIEK.

STRAWMAN: You lost your cap and feathers! How?

JASIEK: Maybe, picking up that cap,
 I somehow caused the thing to snap.

STRAWMAN: Peasant, you had the Golden Horn!
 Your feathered cap you had besides;
 the storm-wind blew it off your head.

JASIEK: Without my feathers, I'm bereft!

STRAWMAN: The Horn?! The strap is all that's left!

JASIEK: I'll find it near the wayside shrine –

STRAWMAN: Someone was standing by the statue..?

JASIEK: Cross-roads are haunted! I forgot!
 Did the cock crow yet – or not?

*Runs out through the door to the wedding-room, forcing
his way through the motionless throng. His footsteps can
be heard from the hall; he pauses to consider, then runs on.
STRAWMAN follows in his tracks, his straw rustling as he
jostles the crush.*

Orchard and fields are bathed in a sapphire light, like blue fire. Pre-dawn twitter of birds can be heard. Blue light fills the room as though casting a colourful spell over the people, now frozen in attitudes, half-sleep, half-trance. JASIEK re-enters by the door at the back, looks about him, unable to believe his eyes and covers his face in fear.

SCENE 36

JASIEK.

JASIEK: Day is breaking; it's the dawn.
 Here, it's time to feed the stock,
 thresh and cook all round the clock;
 how can I manage on my own?
 They're all asleep and I'm alone.

 Everything's open to the wind,
 here they stand with ears still cupped –
 breathing might as well have stopped –
 like fruit trees in the orchard grown!
 How am I meant to cope alone?

 Somewhere, that Golden Horn I lost:
 maybe where the highroads crossed;
 that fearful storm-wind snatched my hat –
 without my feathers, I'm bereft;
 I might have kept the Horn at that –
 but now, the strap is all that's left!

 Something worried them, all right –
 the way they're frowning in their sleep,
 as if they'd been at work all night!

SCENE 37

Through the door at the back, STRAWMAN enters in footsteps of JASIEK, scrambles on to the painted chest and addresses the bridesman.

STRAWMAN: Fear and terror gripped them so,

 when they heard the Spirit call,
 Fate spread its mantle over all.

JASIEK: They're in pain, they stream with sweat,
 faces growing paler yet;
 how can we free them from their woes?

STRAWMAN: The scythes – must first get rid of those!
 Loose their sword-belts, seize their arms –
 that will banish their alarms.
 On each forehead make a circle;
 place the fiddle in my hands,
 then I myself will start to play:
 I'm a maestro in my way!

JASIEK: (*Who has been gathering the scythes etc.*)
 Where'll I put these?

STRAWMAN: Anywhere!

JASIEK: (*Piling them behind the stove.*)
 Nobody'll find them hidden there.

STRAWMAN: Unload the muskets, hide the shot –
 into the cellars with the lot!
 Stretch your left foot out behind
 and draw a circle with your boot.
 In such a way, let hands be placed,
 each grips the other round the waist;
 the Lord's Prayer – wrong way round – recite,
 then I, myself, will start to play –
 to play so mightily that they
 will dance for a year – not just tonight.

JASIEK: (*Who has been following instructions.*)
 I've taken all their scythes and tools –

STRAWMAN: Thumb your nose at them, the fools!

JASIEK: Sadness has already fled –

STRAWMAN: Shackles they've already shed –

JASIEK: Partners wait to take the floor –

STRAWMAN: Wounds inflicted ache no more –

JASIEK: The spell is past!

STRAWMAN: A new spell cast!

The enchanted figure of the STRAWMAN, clumsily grasping in his straw-covered stumps, the sticks handed to him by JASIEK, now assumes the attitude and gestures of a fiddler in action. Wedding music, quiet but lively, can be heard, as it were emanating from the blue atmosphere – a strange melody appealing to the heart and soothing the soul, lazily entrancing, yet as vital as blood, with the beat of an irregular pulse, spurting from an open wound: a melodious sound, familiar from the cradle, an expression of pain and delight rooted in the soil of Poland.

JASIEK: (*Now happy and gazing in wonderment.*)
 So many couples – first to last!

STRAWMAN: Like puppets dancing, there they go!
 Don't you want to join the show?

JASIEK: (*Clapping his hand to his head as though to push his cap over one ear.*) Where's my cap, I'd like to know?!
 As bridesman, I must look my best;
 can't be seen without my crest!

STRAWMAN: (*Swaying in time to the music as he plays.*)
 You oaf! You had the Golden Horn!
 You oaf! You had your feathered cap
 which was stolen by the breeze.
 The Horn resounds among the trees –
 you're left with nothing but the strap!
 All you're left with is the strap!

Cock crows.

JASIEK: (*As though receiving a blow, comes to his senses.*)
 O Jesus, Lord! The cockerel sings!
 Brothers all! To horse, to horse!
 To arms! To arms! Turn out in force!
 Our destiny: THE COURT OF KINGS!!!

STRAWMAN: (*Still swaying as he continues playing.*)
 All you're left with is the strap! You oaf! You had

the Golden Horn!

JASIEK: (*Shouting himself hoarse.*)
 To arms! To arms! To horse! To horse!!

To the haunting sound of the wedding music, the many couples join in a slow, solemn, peaceful, serene, almost silent dance. There is barely a rustle from the stiffly starched petticoats and the long ribbons, hardly a tinkle from the tinselled headdresses worn by the bridesmaids. Dull thumping of heavy boots. They dance close together brushing against the open circle of tables as they squeeze past.

JASIEK: They hear nothing, not a sound,
 save the music of the dance –
 as though asleep, or in a trance...

His breath fails him. Overcome by despair, fright and terror, he falls into a torpor; shields himself with his arms, sinks to the ground, jostled by the dense ring of dancers, which he has vainly tried to pull apart. With a hollow sound, the dancing couples continue moving stiffly, forming a kind of solemn wedding garland – slowly, serenely in an open circle.

Cock crows.

JASIEK: (*Vacantly.*) Cock-crow! Cock-crow... Where's my cap?

STRAWMAN: (*Playing indefatigably.*)
 You oaf! You had the Golden Horn...

The End.